'Bright, colourful, informative and intriguing...Full of Hockney's musings on art, as well as being gorgeous to look at'
Andrew Marr, The Art Newspaper

'Hockney and Gayford's exchanges are infused with their deep knowledge of the history of art...a charming book...teaches you to look harder at the things around you'
Lynn Barber, The Spectator

'Designed to underscore [Hockney's] original message of hope, and to further explore how art can gladden and invigorate... meanders amiably from Rembrandt, to the pleasure principle, andouillette sausages and, naturally, to spring'
Daily Telegraph

'Lushly illustrated...the talk flows effortlessly. The conversations take in everything from Hockney's fondness for tripe and cigarettes, and Van Gogh and Monet, to music and iPad pictures. Hockney is always interesting on art, possibly because he is both unusually thoughtful and exceptionally lucid, so the chats, seamlessly directed by Gayford, are full of fascinating detail about a range of painters rather than just this displaced Yorkshireman'
New Statesman

'Gayford records what the artist saw, thought, read and remembered during lockdown in his French cottage, as reported by email and phone; their conversations read easily and optimistically, spanning nature, food, art, opera, fairy tales'
Jackie Wullschlager, Financial Times

'A paean to the promise of art and the capacity of nature to heal, renew and offer answers in difficult times...The subjects on every page burst forth like spring bulbs, covering everything from the sight of raindrops on a pond to the work of great artists and the rhythm of daily life'
Monocle

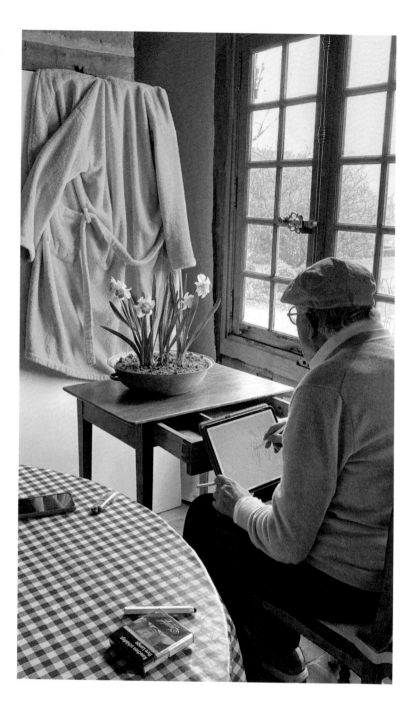

David Hockney
and
Martin Gayford

SPRING CANNOT
BE CANCELLED

David Hockney in Normandy

with 142 illustrations

Page 2: David Hockney making an iPad painting in his house
at La Grande Cour, Normandy, 20 March 2020

First published in the United Kingdom in 2021 by
Thames & Hudson Ltd, 181A High Holborn, London WC1V 7QX

First published in the United States of America in 2021 by
Thames & Hudson Inc., 500 Fifth Avenue, New York, New York 10110

This compact paperback edition published in 2022

Spring Cannot be Cancelled: David Hockney in Normandy
© 2021 Thames & Hudson Ltd, London
Texts by Martin Gayford © 2021 Martin Gayford
Texts by David Hockney © 2021 David Hockney
Works by David Hockney © 2021 David Hockney

Edited and designed by Andrew Brown

British Library Cataloguing-in-Publication Data
A catalogue record for this book is available from the British Library

Library of Congress Control Number 2021931490

ISBN 978-0-500-29660-8

Printed and bound in Slovenia by DZS-Grafik d.o.o.

Be the first to know about our new releases,
exclusive content and author events by visiting
thamesandhudson.com
thamesandhudsonusa.com
thamesandhudson.com.au

MIX
Paper from
responsible sources
FSC
www.fsc.org FSC® C106600

CONTENTS

22 October 2018

Dear Martin

We are now back from France, where we had a wonderful time. We left London at 9.30am and drove to the Tunnel. With our Flexiplus tickets, we could just drive straight onto a train without stopping. We were in Honfleur by 3pm or 4pm local time. We then watched a magnificent sunset over the Seine estuary.

Next we saw the Bayeux Tapestry – a marvellous work without a vanishing point or shadows (when did they begin, is my question to the art historians?). We then went to Angers and saw the Apocalypse Tapestry (also no shadows), and then in Paris we saw the unicorn tapestries. So within a week we had seen three of Europe's greatest tapestries.

In Paris, we also saw Picasso's Blue and Rose periods at the Musée d'Orsay, and then went to the Pompidou and saw about eighty paintings in the Cubist show – so his work from the age of twenty to thirty. A magnificent achievement.

The food was fabulous – all that delicious butter and cream and cheeses. We also found France a lot more smoker-friendly than mean-spirited England. In fact, I've decided to do the arrival of spring in Normandy in 2019. There are more blossoms there: you get apple, pear, and cherry blossom, plus the blackthorn and the hawthorn, so I am really looking forward to it.

Love
David H

I

An unexpected move

I have known David Hockney for a quarter of a century now, but we live in different places – and always have done – which gives our friendship a certain rhythm. For long periods, it is conducted at a distance, by email, phone calls, an occasional parcel – and a steady stream of pictures that arrive almost daily in my inbox. Sometimes, when he is in an intense phase of activity, there may be three or four images together, showing a work at various stages of completion. Occasionally there is a joke or a story from the news that has caught his attention. Then, when we meet again after months or even years, our conversation resumes as if there had been no interruption. Except there is a constant, almost imperceptible, shift in perspective.

Over the many years that we have been talking with one another, innumerable things have happened around us, while we have also become older, naturally, accumulating new experiences as we do. The result is that even if we are contemplating something that we had discussed long ago or more than once, a particular picture for instance, the place from which we are doing so is novel, because it has never existed before. That place is *now*. Perspective, in this sense, affects not just pictures and how they are made – a perennial topic for David and me – but all human affairs. We see every event, person, and idea from a certain vantage point. As we move through time and space, that position alters, and consequently so does our angle of vision.

Before October 2018, when I received the email opposite, he and I had last spent hours in uninterrupted conversation two years earlier, when we had published a jointly written book

entitled *A History of Pictures*, and I had stayed with him in his house on Montcalm Avenue in the Hollywood Hills. Since then, time had flowed on. The following year, he had turned eighty, prompting a succession of exhibitions around the world – in Melbourne, London, Paris, New York, Venice, Barcelona, and Los Angeles – which amounted to a global lap of honour. This made for a full schedule. In the intervals between grand openings and interviews, he was also very busy in his studio, making several series of extraordinary pictures and also a number of intellectual discoveries. In June 2017, at the time of the British general election, for example, my wife Josephine and I were travelling in Transylvania. In amongst news from home about the state of the polls, a message from California suddenly popped up on my phone. It concerned perspective systems and an art theorist of whom I had not heard.

> Dear Martin
> Do you know Pavel Florensky, a Russian priest,
> mathematician, engineer, and scientist who wrote
> about art? He wrote a terrific essay on reverse
> perspective. It appears that perspective was first used
> in the theatre (Greek). I have pointed out the connection
> between photography and the theatre: they both need
> lighting. Anyway, he's a very interesting writer who
> lived at the wrong time – a kind of Russian Leonardo.
> He was shot by Stalin in 1937.
> Love
> David H

Attached was a text eighty or so pages long, the reading of which on an iPhone in the Carpathian Mountains posed quite a challenge. Nonetheless, I had a go. It turned out to be highly intriguing. Florensky argued against the notion that there is

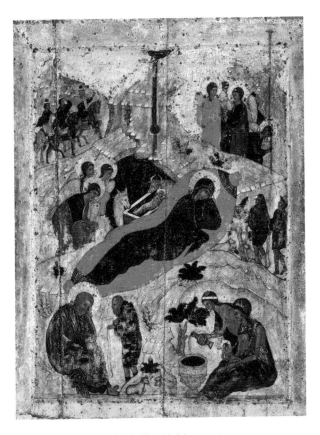

Andrei Rublev, *Nativity*, c. 1405

only a single, correct variety of perspective: the 'Renaissance' or 'linear' type, first demonstrated by Filippo Brunelleschi in the early fifteenth century, with a single vanishing point. Instead, he insisted that the way of depicting space in medieval Russian icons, such as those by Andrei Rublev, was just as valid. These pictures did not have one fixed vanishing point; they were 'polycentred'. By this, Florensky meant that 'the composition is constructed as if the eye were looking at different parts of it, while changing its position'. It was not hard to understand why this essay had struck such a chord with Hockney. This was a way of constructing a picture that he had been exploring for forty years. It was the basis of his photocollages of the 1980s and the eighteen-screen and nine-camera films of around 2010. That first email was followed a few days later by another.

> Dear Martin
> Have you read the Florensky essay on reverse perspective yet? It's quite dynamite. It's amazingly thorough and very clear. If you keep the last paintings I sent you in mind, you will understand it. I think we've discovered a great writer on art. No one knew him; not one art historian I've talked to had heard of him. This is sad. I know reverse perspective sounds a mad idea, but I recommend his book called *Beyond Vision*. The reverse perspective essay is the last one in the collection, but all are fascinating and compelling.
> Much love
> David H

Hockney's enthusiasms are imperious, sweeping along not only his friends, dealers, and helpers, but also many members of the art-loving public. Ultimately, perhaps, he will affect the received opinion about what happened in the past, which artists,

techniques, and movements were 'important' and which were not. But he has never been too concerned about what history or critics had to say, which has been a source of strength.

DH I've witnessed quite a few changes in the art world and, you know, most artists are going to be forgotten. That's their fate. It might be mine too, I don't know. I'm not forgotten yet. It's OK if I am; I'm not sure it's that important. Most art will disappear. The past is edited so it always looks clearer to us. Today always looks a bit of a jumble. We'll put up with rubbish from now, but not with rubbish from the past. I know that another age will see this period in a different way. Very few people know what the truly significant art of today is. You'd have to be an incredibly perceptive person to do so. I wouldn't make a judgment on that. The history books keep being changed.

It seems to me that it is often artists who alter the storyline in those histories, by doing something fresh that takes us to a different place from which the view of everything else is transformed. The younger Hockney, though always renowned, considered himself and was considered by many art observers as 'peripheral'. Perhaps he was. He certainly avoided all movements and fashions. At an early exhibition opening, he went so far as to stand up and announce that he was not a pop artist (that is still how he is sometimes described by journalists, nearly sixty years later). Just at the moment when this book begins, in the autumn of 2018, his *Portrait of an Artist (Pool with Two Figures)* sold for a record-breaking figure, making it the most expensive work ever sold by a living artist at auction. Did that matter? It was an event assiduously ignored by the artist himself, except to quote Oscar Wilde's observation, 'The only person who likes all kinds of art is an auctioneer.' It is always

the next picture, the new discovery, whatever it is that comes next, that animates him. This is, after all, a natural and psychologically essential attitude for any creative person. Once you start looking back, you have stopped moving forward; and what is proverbially said of sharks is true – at least metaphorically – of artists: if your forward momentum ceases, you die.

Hockney has not been concerned to cultivate a 'signature style', reflecting when people remark that his latest work does not look like a Hockney that 'it will' (he's right about that). But in some other ways, he doesn't vary much. Recently, I found the first conversation that we recorded, a quarter of a century ago, on a dusty cassette at the bottom of a cardboard box. When I played it, I discovered that although his voice was lighter, he was saying then many of the things that he is still saying now: about the inadequacies of photography, for example, and the value of drawing. But every so often, he said something completely unexpected, a thought that no one has had before – and perhaps no one else would ever be likely to have.

That is still going on now. On the morning in October 2020 on which I am typing these words, two new works arrived via email from Normandy. His recent pictures continue to provoke novel thoughts in him, and in me. As a writer principally concerned with art and artists, I am carried on by the energy of a new subject, a fresh body of work or historical period. Some of the artists about whom I have written, though long dead, I feel that I know almost as friends (no doubt this is a biographer's illusion). With a contemporary artist, though, it is different, because they and their work are still evolving.

That's why biography of a living subject is a dubious enterprise; Lucian Freud objected to the idea of his life being written on the grounds that 'it is still going on'. Moreover, as Hockney points out, Lucian spent most of his time in his studio, and what happens there – looking, thinking, making pictures – 'can't be

got across that well in a biography'. Of course, that's true of him also. In his case, both life and art are still developing in real time as I write, so this is not a biography. It's more a diary of works and conversations, the novel vistas they revealed, and the thoughts they set off in my mind.

After completing two books on and with David, I might have thought I knew him and his work. But over the past two years, his pictures and ideas have taken me off in all sorts of unexpected directions – geologically, astronomically, into liter-ature, optics, and fluid dynamics. Meanwhile, the whole world has suffered a disastrous pandemic, which has changed all of our points of view. Those novel vistas are the subject of this book: the new things said and done by an old friend, and the thoughts and feelings they prompted in me.

*

To understand Hockney's new life in France, however, it is useful to know what he had been doing in the years and months before his move. Throughout the six or so decades of his career, he has been carried forward by recurrent gusts of enthusiasm. He likes to quote his erstwhile assistant Richard Schmidt, who used to say, 'What you need, David, is a project!' I know the feeling; I am a little aimless myself without a book to write and a subject to delve deeper into. I seem to need to be learning or doing something fresh; I suspect Hockney is the same.

For him, such a mission usually takes the form of a new cycle of work. Thus the period from the end of 2013 to 2016 was filled with his sequence of *82 Portraits and One Still Life*, not just a single painting, but a whole gallery of them. The unfold-ing of such a scheme leads from one picture to the next, but often it is also a form of study. One of his most ambitious enter-prises – the investigation into art history that led to his 2001

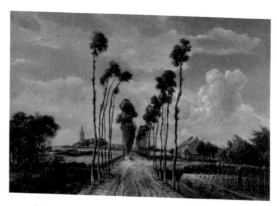

Meindert Hobbema, *The Avenue at Middelharnis*, 1689

book *Secret Knowledge* and then on to our *A History of Pictures* – was essentially historical research (although it resulted in a series of new paintings and drawings as well). Similarly, his discovery of Pavel Florensky in 2017 touched off a group of works in which he revisited his own earlier images and also a couple of old masters, opening out the space and breaking away from the rectangular shape and right-angled corners of a conventional Western picture.

One of the works he exploded in this way was *The Avenue at Middelharnis* by the seventeenth-century Dutch landscape painter Meindert Hobbema. On the telephone one Saturday afternoon, Hockney explained to me that he had always loved this picture, which is part of the collection of the National Gallery in London. He had long noticed that it had not one viewpoint but two: 'The trees are so close to us, aren't they? Therefore, you must be looking *up* as well as looking *on.*' His own painting of the view – on six shaped canvases – was a

Tall Dutch Trees After Hobbema (Useful Knowledge), 2017

combined deconstruction and investigation of Hobbema's space, into which the viewer seems to walk. You go down that avenue, looking right and left, as well as up into the sky and down the road. 'Just chopping off the corners has done wonders for me because now I can compose *with* all the edges, in all sorts of ways too – and make space! I'm very excited by it.'

The excitement ignited by a long-dead Russian's essay carried on through the rest of that year, and the impetus led to a remarkable series of pictures he dubbed 'digital drawings' – virtual collages made of innumerable photographs stitched together on a computer screen. Then, in the autumn of 2018, he was back in London. The impulse was the unveiling of a stained-glass window he had designed for Westminster Abbey. This was celebrated at one of the most unusual art openings I have ever attended, first in the transept of the famous Gothic church, then at a reception in the cloisters attended by friends, family, and a sprinkling of well-known artists.

Under the medieval arches, Hockney mentioned that he was just about to go on a journey to France, but that he would be back in London a week or two later and then would stay for a while. With him, a change in place can often signal an alteration in his work, a prelude to a new enterprise. He seldom travels just for the sake of travel. Once when he was about to set off on a journey and I wished him a good holiday, he was offended, replying, 'I haven't been on a holiday for twenty years!' On the face of it, though, this trip sounded like a pleasure jaunt. But perhaps it was more about, if not exactly work, prospecting for new subjects that might turn into a project. No sooner had he returned to London than the email at the beginning of this chapter appeared, announcing exactly that: a grand, ambitious idea – 'the arrival of spring in Normandy in 2019'. So it seemed that at eighty-one, he was eagerly planning next year's activity. Before long, it emerged that he had something even more in mind: a whole new phase of life.

In early November 2018, David decided to prolong his stay in Britain, so for a while he stayed on in his London home at Pembroke Studios in Kensington. He continued with a series of portraits that he was doing, drawn in charcoal and crayon on canvas. I dropped in for tea, and met his model for the current picture, an old artist friend of his named Jonathon Brown. An evening or two later, I met them both at a dinner inaugurating an exhibition of work by Richard Smith, a somewhat older contemporary of Hockney's. He and his party were sitting outside, smoking, when I arrived. We were seated at different tables, and didn't have a long chat then, so it wasn't until we met for dinner a few days later that the full scope of this new step became clear. He was not just going to spend more time in France next year, making pictures of the changing seasons, he had even bought a house in Normandy. This implied that, for some of the time at least, he was going to live there. He gave an enthusiastic account

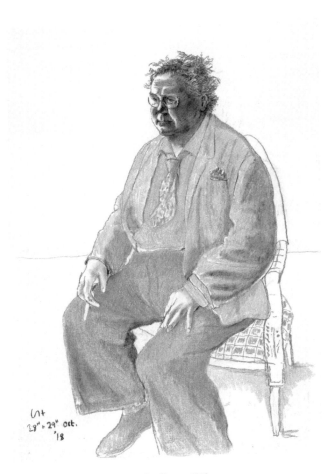

Jonathon Brown, 2018

of how it had come about as we sat in his studio, and while he did so another guest, David Dawson, sometime assistant of Lucian Freud's, a painter and also a photographer with an artist's eye, snapped us talking. Hockney was buoyed up by the excitement of having found this place and then immediately buying it.

DH It happened like this. We travelled to Normandy after the stained-glass window at Westminster Abbey was opened. We went through the Eurotunnel, via Calais. We stayed in this lovely hotel at Honfleur, where we saw this sunset. We sat there for three hours watching it. It was like van Gogh's paintings: you could see everything very clearly. The sun was behind us, lighting everything up.

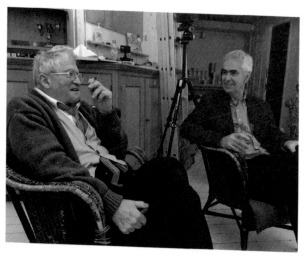

David Dawson's photograph of the artist and the author in the studio, 2018

This makes it sound as if it was, partly at least, the light that attracted him to north-western France, which is for an artist among the best of reasons to travel (the sun of Provence was one of the lures that attracted Vincent van Gogh south to Arles). The decision to buy a house was apparently made on the spur of the moment. But, as Sigmund Freud argued, short of lightning strikes, there is no such thing as an accident. So it was surely not entirely chance that an artist long admiring of French painting and the Gallic way of living, eating, and smoking, with a French assistant, happened to find an ideal resting point just where and when he did.

The assistant in question is Jean-Pierre Gonçalves de Lima, known affectionately as J-P, Hockney's principal aide and, increasingly, the mainstay of his existence. He has been part of the artist's world for a long time now. There is a drawing of him from 1999, one of a series done with the nineteenth-century optical tool known as a camera lucida that was a prelude to Hockney's research for *Secret Knowledge*. J-P was already in London and working as a musician. He is an accordionist and had an excellent band that played an updated version of Django Reinhardt and Stéphane Grappelli's idiom ('Grappelli was an absolute genius!', J-P once exclaimed to me). An enthusiasm for this kind of music, as well as for David's pictures, is something that he and I agree on.

After he met Hockney, J-P's interests were diverted towards art, and a corner of provincial England. He was a crucial part of the artist's team in Bridlington, arranging the studio and the mobile painting equipment. In fact, he made the rich decade of landscape work there possible. One of his most important contributions, however, was to recruit Jonathan Wilkinson, whose expertise has rendered a whole new terrain of high-tech media accessible to Hockney.

DH We stayed at Honfleur for four nights, and then we went on to Bagnoles-de-l'Orne further south. On the way there, I said to J-P, 'Maybe I could do the arrival of spring here, in Normandy.' I could see that there's a lot more blossom there. So I suggested that perhaps we should rent a house or something. The next day, he rang some estate agents. We were on our way to Paris, when he said that we could see a house en route. It was the only one we looked at. It was called La Grande Cour. When we came in and saw the higgledy-piggledy building and that it had a tree house in the grounds, I said, 'Yes, OK – let's buy it!' Then a moment later, I had some doubts. I thought, 'But will it be cold? Hmmm, this house might be quite cold.' But J-P said, 'I'll make sure it's *warm*!'

Hockney is an enthusiast for Bohemian society, but not for the discomfort that often goes with it. He craves the isolation that van Gogh experienced in his little Yellow House at Arles, living surrounded by his subject matter and able to concentrate utterly on painting it, but not the Spartan simplicity: no heating apart from a stove in the kitchen, no bathroom at all. In Bridlington, he used to talk about wanting 'Bohemian life with a bit of comfort'. And indeed, his living conditions there were – from my point of view, as a fellow sybarite – delightfully snug.

Jonathan joined us in the studio for a glass of champagne, and then we walked over to an Italian restaurant on Kensington High Street, chosen not only for its food but also because it had an outdoor pavement area where smoking was permitted. For most of his life, Hockney has been an urban dweller. Even during his decade in East Yorkshire, although he was painting, drawing, and filming the countryside, he was based in a small seaside town. Now, however, it seems he is after something else: rustic tranquillity.

Over Christmas and New Year, he returned to California to renew his green card and to continue with his series of drawn portraits on canvas. He also had a major exhibition to prepare at the Van Gogh Museum in Amsterdam, entitled *The Joy of Nature*. This show opened towards the end of February 2019, and as usual with David, who makes headlines without intending to, there was a great deal of media hoopla at the time of the opening. Annoyingly, I had gone down with flu, and as a result I missed out not only on seeing the exhibition but also on what turned out, unexpectedly, to be an international news story. Hockney, with rather too many people trailing behind him, got stuck in a hotel lift. Eventually, they were all rescued by a team of Dutch firemen. Evidently, the incident couldn't have been better located for media coverage; indeed, afterwards David ironically thanked his publicist for having arranged for the lift to malfunction. Nonetheless, the affair was testimony to the

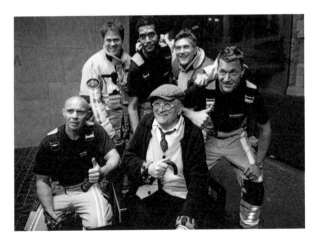

Hockney and the Dutch firemen posing for photographers, February 2019

remarkable penetrative power of his fame – reaching parts that other artists' renown cannot. It is hard to imagine that if, say, Jeff Koons, Gerhard Richter, or Damien Hirst were inconvenienced in the same way it would cause such a media furore.

His old friend Melvyn Bragg once mused to me that, 'David has been famous, more or less continuously, since he left art school; that's not bad and it's not necessarily good, but it is very unusual.' It is true. Other artists, even highly celebrated ones, usually experience intervals of obscurity. Francis Bacon, for example, did not attract much attention until he was in his mid-thirties. But for nearly sixty years, Hockney has never not been a focus of attention.

At a moment of pressure, with a string of people appearing one after another at his studio to be talked to and entertained, he lamented, 'I don't *like* being famous!' (J-P immediately sang out, 'Prima donna!'). Hockney has lived with celebrity for a long time, and he has a recognition factor that cuts through far beyond the art world, and is connected not only with his art, but also with him – his voice, his wit, his appearance. Many artists have cultivated a distinctive 'look' – Whistler's monocle and lock of white hair, Gilbert & George's buttoned-up suits – but Hockney is unique in having evolved a series of ways of dressing over decades that all look quite different, but are all identifiably his style. His 1960s gear, the velvet jackets and bow ties of the 1970s, and the loose, baggy outfits that he adopted in the 1990s have little in common with the cloth cap, yellow glasses, and designer knitwear that he usually sports these days – except that they all look like David Hockney's clothes and no one else's. I would guess that his personal style comes naturally from a desire to dress the way just as he likes and an indifference to what other people do. His views on current fashions resemble his opinions on photographs: that, generally, they aren't interesting enough.

DH Today, everybody's in gym clothes. Fashion's gone very dull, I think. When I was about sixty and I saw men of seventy wearing blue jeans, I used to think, 'Well they are trying to look like teenagers', but now everyone does, even eighty-year-olds. Not me; I don't have a pair of jeans.

It's the same with his tone of voice and turn of phrase, which are so distinctive they ring out from the printed page. Likewise, his contrarianism and what he calls 'my chirpy cheekiness' are instinctive traits, inherited from Kenneth Hockney, who went on the Aldermaston marches against nuclear weapons, and did so carrying his own handmade placards against smoking.

DH I'm a bit of a propagandist; that's from my father. My old friend Henry Geldzahler used to insist that I was always saying, 'I know I'm right.'

One of the first remarks that Hockney made to me on that tape from 1995 was, 'As usual, people have got it all wrong.' He was talking about the alleged death of painting and the rise of photography. Such a propensity to take an opposing position, even if hereditary, is an enormous asset to an artist. To carry on following one's own distinctive path through decade after decade of fluctuating art fashions requires immense reserves of inner confidence. Nonetheless, the reason why his renown is so pervasive and enduring is mysterious even to him. There is an old BBC interview in which he is asked, 'Mr Hockney, to what do you attribute your enormous popularity?' There is a pause, then he confesses, 'I'm not that sure.' No doubt it can be a burden, as well as a boon. It is perhaps part of the reason why – quixotically it might seem – he craves companiable solitude.

A few days after the lift incident, in early March 2019, Hockney, J-P, and Jonathan were there, at La Grande Cour.

No sooner had they arrived than a stream of pictures began appearing in my inbox, often marked 'No subject', but sometimes with a brief explanatory caption. For the next few months, David told his story, as the Bayeux Tapestry does, mostly in pictures. Like a child on holiday, he had woken up early to begin exploring this exciting new place in which he found himself.

He was evidently so happy, and so productive, that I and many of his friends were loath to disturb his peace. Months passed by. In July 2019, Josephine and I went to Brittany on a completely different mission, prompted by another book, about sculpture, to see the prehistoric monuments around Carnac. We had a delightful time exploring standing stones and the Breton coast. Before we set out, glancing at the map, it had struck me that Hockney's new house was not far away. On impulse, I sent a message asking if I could drop in.

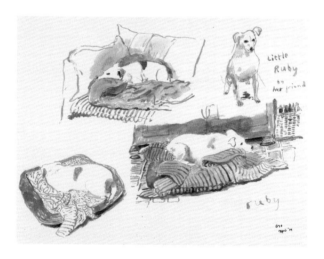

Little Ruby, 2019

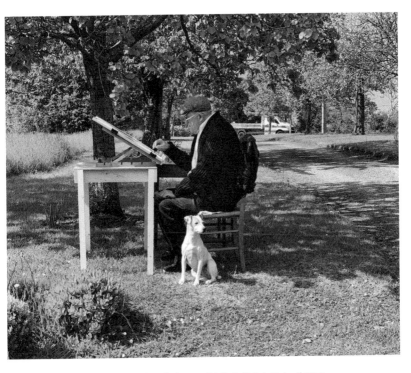

'Here I am drawing the house with little Ruby', 29 April 2019

In Front of House Looking West, 2019

The answer was an invitation to come and stay (though I would sleep at a nearby farm, since there was no guest room). So Josephine, who had to get back to work, flew home, and I climbed on a cross-country train at Dol-de-Bretagne.

The journey – which looked fairly short on the map – turned out to be immensely leisurely. At one point, the carriages chugged into Granville station and waited for a good half hour before reversing out again and resuming its slow progress. Meanwhile, by means of a series of texts to Jonathan, I arranged to meet them at Caen station, which was on my route.

They pulled into the forecourt, Jonathan driving, and I got into the car. Hockney was not at all talkative on the trip to his domain, probably because he had trouble hearing what I was saying, since I was sitting in the back. As soon as we arrived at La Grande Cour, though, that changed. When we got out of the car, he suggested a visit to his new studio, and conversation instantly began.

2

Studio work

DH J-P came here on 15 December, and moved in on 7 January, when they gave him the keys. On 15 January, the workmen started on converting this studio. He wanted it done as quickly as possible, and he nattered at them and nattered at them and nattered at them ['natter' is a favourite word with DH, meaning to talk to someone about something incessantly until they give in and do it]. He told them, 'This is a studio for David Hockney, who wants to do the arrival of spring here in 2019, not 2020!' Now they all look me up on Google, so they can see the work.

To get the studio finished, J-P used a notary who arranged things more quickly. It was all completed in three months. He needed help from the authorities, otherwise it might have taken four or five months; but J-P just got on with it, then the notary OK'd it. At one point, he had fourteen vans here, with fourteen different contractors, and he dealt with everything. He's done a great job – he's made this place fantastic!

The stairs weren't in when I arrived at the beginning of March, and the floor only went down at the end of the week before. There were still lots of workmen around. But I drew the first of several concertina drawings and twenty-one other drawings in three weeks because I wasn't interrupted once by anybody. At night, I'd go to bed planning what I was going to do next. So I always had it in my head. I'm not sure I'd have been able to do those drawings so rapidly if I'd had more visitors.

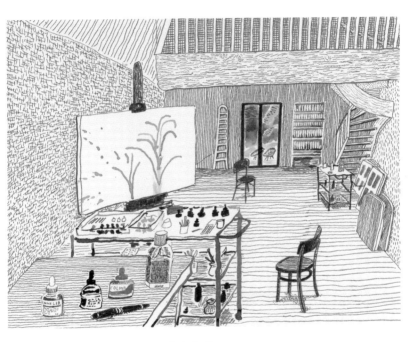

In the Studio, 2019

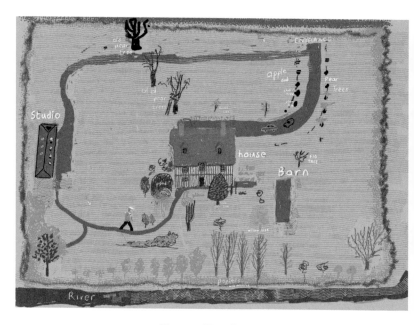

No. 641, 27 November 2020

Every artist's studio is different because it is a reflection of their personalities, habits, and, above all, what they need to do: their work. Some are huge, others tiny; some are orderly, others chaotic. Each of Hockney's studios that I have seen (this is the fifth) has had its own particular qualities. In Bridlington, he began to work in a cramped, improvised space tucked away under the eaves of the house where he was living, which had previously been a small hotel. Then, as the scale and ambition of the pictures that he was doing grew, it became obvious that he needed a larger place to make them. J-P devised the second, enormous workplace, a vast space on an industrial estate in which the huge pictures presented in Hockney's 2012 exhibition at the Royal Academy of Arts in London, *A Bigger Picture*, were painted.

This studio in the Normandy countryside is a working environment tailored to a painter who, like all important artists, is unique in his attitudes, creative rhythms, and practical requirements. Moreover, the space is perfectly adapted to his needs and interests right now, in his early eighties. It is a studio in a landscape, immersed in the natural world, in the midst of silence and living plants.

MG It's more like Paul Cézanne's studio in Aix-en-Provence, surrounded by trees, close to all his subjects. He could walk to them, carrying his canvas and paints.

DH I've been to Aix and saw where he worked. It's not that big, but it's a *proper* studio with a north light. Here, I am right in the middle of *my* subject. Sometimes I work outside. For example, I began some drawings outside from observation, looking at the trees, but then I did the dots of the gravel road and path inside – it takes a long time to do those.

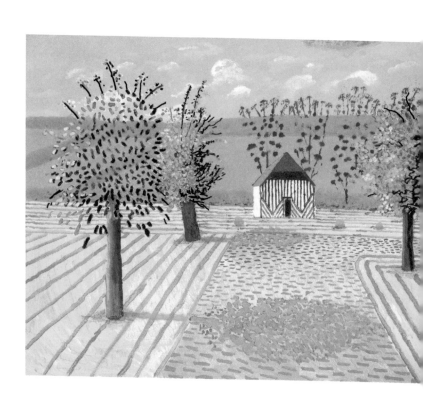

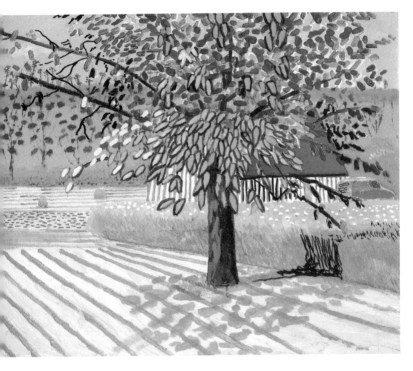

The Entrance, 2019

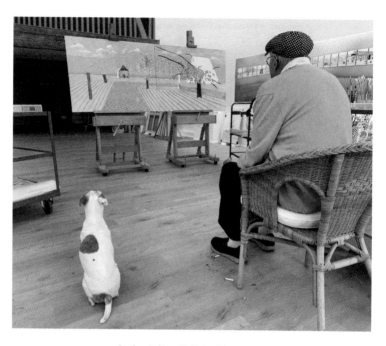

In the studio with Ruby, May 2019

When J-P first came here, he told me, he realized
that we wouldn't have to drive anywhere, whereas in
Bridlington I had to get in the car to go to my subjects.
That's why we got it. It makes an enormous difference
because I get to know the trees a lot better. I'm *always*
looking at them. *Always*. This afternoon I might draw
the apple trees and pear trees again because now they
have fruit on them, hanging there. Trees are fascinating
things. They are the largest plant. Every one is different,
like we are; every leaf is different. In Yorkshire, one day

a guy asked us why we were always filming the trees; he thought they were all the same!

MG I should think that's quite a common point of view.

DH It is. Ronald Reagan said that when you've seen one redwood, you've seen them all. But actually they are all individuals, like us. Being surrounded by the trees and getting to know them, just by looking at them, you realize why their shape is the way it is, what the reason for it is. Those trees over there had a lot of mistletoe in them. It looks like a bird's nest, but it isn't. It kills the trees, actually. We were told some of them were dead already, but they are not yet. They have lots of leaves coming out. That tree on the right is a cherry and it blossoms first; it's out in late March. The pears are next, then the apples. They have a cider route here that comes this way; you drive through all the apple trees in blossom. It's lovely. Most of them are massed together in orchards.

Right now, I need to be somewhere like this. When I signed the lease on the Bridlington studio a decade ago, I felt twenty years younger, and the same thing happened here. I feel revitalized. It's given me a new lease of life. I used to walk with a stick, but since I came here I've forgotten about it. In fact, I didn't remember to take it with me to Los Angeles when I went there recently. I'm getting more exercise here. I can see that from the steps that are counted by my phone. I walk about a mile a day just by going from the house to the studio. And I walk a long way in this garden. You can walk two miles around it easily. Sometimes, I walk up to the gate or down to the little river across the meadow before I come here to the studio. If we go off the property, it's a bonus!

The little roads are lovely, you can go down any road –
any – and they are all beautiful. Most of them are tiny.
The motorway is about sixty-eight miles away, so we
can go to Paris in two and a quarter hours. J-P's gone
a few times; he's there now. He's gone for a little rest. But
I haven't been to Paris much since I came. I stay here.

I think I've found a real paradise. This place is perfect
for me right now. I'm less interested in what other people
are doing. I'm just interested in my own work. I think
I'm on the edge of something, a different way of drawing
is coming through, and I can do it here. I couldn't do it
anywhere else: London, Paris, New York. You have to be
somewhere like this.

<p style="text-align:center">*</p>

Hockney is a domestic person, whose various dwellings are
always comfortable and attractive. But though he pays atten-
tion to the other parts of his houses – for example, the pool, the
garden, and the expansive sitting room-cum-dining room in
Los Angeles, all of which have been the subject of numerous
works – the place where he spends most time, the centre of his
existence, is the studio. That is where he works, and generally
where he thinks; and what he thinks about, mostly, is his pic-
tures. He will pause between sessions of painting to sit, look,
and smoke. In the afternoons, he often returns and may just
gaze at what he has done and contemplate. Tacita Dean, his
friend, fellow artist, and English Los Angelino, made a filmed
portrait of him in 2016 – in itself an intrinsically paradoxical
enterprise. It consists of sixteen minutes of Hockney in his
LA studio, doing what he spends a lot of time doing: smoking
a cigarette and musing on his own pictures hanging on the
walls around. Nothing much happens. He simply puffs away

and at one point laughs at his own thoughts. You are watching him thinking: perhaps reflecting on the cycle of eighty-two portraits that he had just completed and that would soon be exhibited at the Royal Academy, some of which are on the wall behind him (including one depicting Dean's young son).

DH I read a biography of Augustus John once, and I thought he spent too much time out of the studio, doing things, arranging things. But it wasn't *studio* work.

In an out-take from Bruno Wollheim's delightful film about the early Bridlington days, *A Bigger Picture*, there is a sequence shot in the loft-studio one evening in which Hockney reflects that he enjoys looking at what he has done. 'I like looking at them. Mo McDermott, my late assistant, used to say, "I am your *second* greatest fan, David." For a while, I thought he meant my mother was the first. But if you didn't like them, you wouldn't go on, would you?' (The corollary to this thought, one that Frank Auerbach has remarked on, is if you didn't think the next work was going to be better than the last, you wouldn't carry on either.)

In the same short sequence, Hockney, while chatting with Wollheim, goes on to say that, 'You paint them all for yourself, really. I think artists always do. Even if it's a commission, they do it their way.' He has said something similar to me: that he understands that people buy and collect his works, and that that is a necessary part of the process, 'But really, I think they are all mine.' There are two diametrically different attitudes that artists adopt to their own creations. Some lose interest as soon as they are finished; others such as Hockney and van Gogh like to be surrounded by what they have made.

A few years ago, in an interview with broadcaster Jon Snow of Channel 4, he mused, 'In LA these days, I just live in the

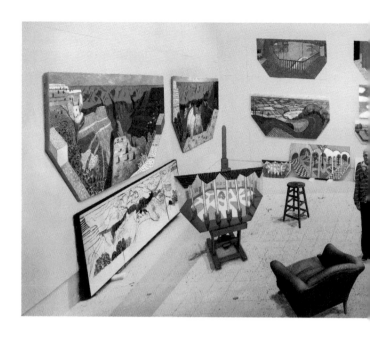

studio really. That's all I want to do.' A series of pictures he has
done in the last few years are meditations on that room, on the
ideas that grow in it, and the way that it is as much a mental
space as a physical one: the place where pictures are made, but
also the one in which they are conceived, and the next develops
from the one that came before. Such a depiction of the studio is
a representation of the artist's world, but also of their interior
landscape. In some of these works, which Hockney calls photo-
graphic drawings, the studio on Montcalm Avenue has been
enlarged to enormous proportions and contains numerous
pictures that had been made within it, some of which were
representations of the studio itself, sometimes crowded with
various friends, assistants, and spectators.

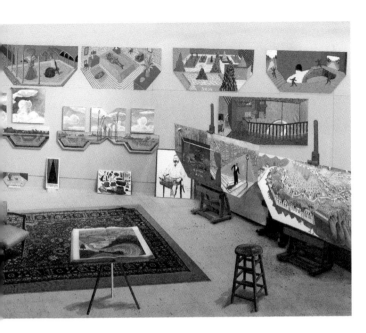

In The Studio, December 2017, 2017

In one such picture, an expanded, panoramic one, Hockney stands in the centre surrounded by an entire cycle of paintings that he produced in a tsunami of activity in the summer of 2017 in the lead-up to his eightieth birthday. This was the series in which he reworked some of his own previous pictures and a few by predecessors such as Meindert Hobbema and the fifteenth-century Florentine Fra Angelico. In every case, he opened up the earlier image by slicing off the bottom corners so as to get rid of the right angles of the conventional canvas. Each separate painting on the walls and easels contained many perspectives, taking the viewer closer to the subjects, into and around the spaces within the pictures. And every single object in the studio itself has its own distinct perspective.

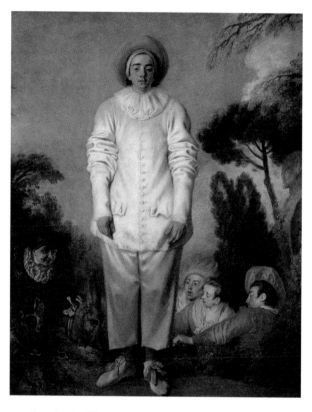

Jean-Antoine Watteau, *Pierrot* (also known as *Gilles*), *c.* 1718–19

DH Every chair in the picture has a vanishing point.
So you *look* at each one. If it were just one photograph
of the whole room, you wouldn't do that.

It was, as he explained to Snow, 'the digits that are doing it.
It's digital photography.' In the period before and after he made
that encyclopaedic, autobiographical picture, which he called
In The Studio, December 2017, Hockney was exploring the
possibilities of such photography together with Jonathan, his
indispensable aide in all matters technical.

DH Jonathan has made a big difference to us. J-P found him,
and I realized that with his help we could do a lot of
things. We've never looked back. We did all those portraits
and landscapes, drawing in the printing machine, and the
iPad works, the films. He's our computer specialist. We
need him; he's now part of our creative team. Without him,
we wouldn't have done the films, putting nine cameras
together; we wouldn't have done the digital drawings.
I wouldn't have started those projects without a technical
person who knew exactly how to do it. Jonathan keeps
saying that there's new software coming out every week
that allows us to do something that we couldn't do last
year, especially new techniques for the works that we're
making. As long as it gets done, I don't care how it
actually happens. But he tells me, 'Well, that would have
taken a few days; now we can do it in twenty minutes.'

Among all the different spaces in that picture, created in various
media by his own hands, and conceived in his head, stands
Hockney, like Prospero encircled by the wonders he has sum-
moned up. The comparison that came to his mind was with a
great predecessor among painters: the portrait of Pierrot by

Jean-Antoine Watteau from around 1718–19. He sent out the juxtaposition of images in a wordless email. Watteau's isolated figure has often been thought to have been a self-portrait of the artist, at least as a poetic metaphor. Hockney would probably agree with Pablo Picasso's remark, 'When I create, the artists of the past stand behind me' (and of course one of those most constantly in his thoughts is Picasso himself).

When conceiving the sweeping composition of the artist amidst his created world in December 2017, however, he was actually thinking of another precedent.

DH I had Gustave Courbet's *The Painter's Studio* in mind.

MG The artist's studio is a rich subject in itself, weaving in all sorts of themes: the making of art and the making of images, appearance, and reality …

DH … inside and outside.

Such paintings form a venerable genre. There are several examples from seventeenth-century Netherlands, for instance. But Courbet's canvas, three-and-a-half metres high and six metres wide, was a novelty. He gave it an extraordinary and thought-provoking title: *L'Atelier du peintre: Allégorie réelle déterminant une phase de sept années de ma vie artistique et morale* ('The painter's studio: a real allegory determining a phase of seven years of my artistic and moral life'). Hundreds of pages of scholarly prose have been devoted to that oxymoronic phrase, 'real allegory'. Effectively, Courbet, like Hockney, was surrounded by his own pictures. The studio he depicted was his workplace on Rue Hautefeuille in Paris, a space as cavernous as Hockney's largest studio (it was in fact part of a converted medieval priory, and what we see is the apse of the chapel).

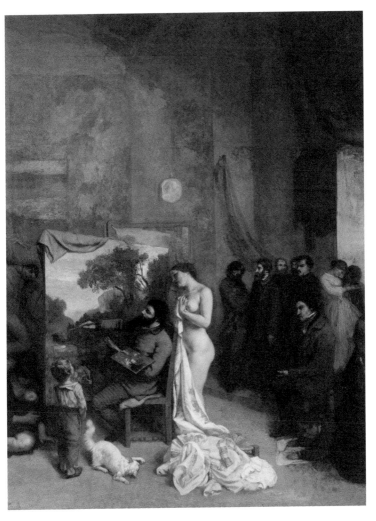

Gustave Courbet, *L'Atelier du peintre: Allégorie réelle déterminant une phase de sept années de ma vie artistique et morale*, 1854–5 (detail)

Georges Braque, *L'Atelier II*, 1949

But Courbet was not there when he was painting the scene; he was at Ornans in his native Franche-Comté in eastern France. He was thus obliged to reconstruct this room from memory. Nor did he have access to most of the sitters who are depicted around him. These are, as the title suggests, real individuals who for the most part had played a role in his life, such as the poet and critic Charles Baudelaire, who is sitting on the far right of the canvas. Most of them were in Paris too. So Courbet, who famously could not do anything without a model in front of him, was obliged to paint those figures from portraits he had already done (in one case, he asked a collector to send him a particular work so that he could copy it). The nude who gazes over his shoulder was painted from a photograph that, again, he had asked a friend to send. Probably a naked model would have been hard to find in rural Franche-Comté, but he felt she needed to be there in the picture.

As a whole, *L'Atelier du peintre* is therefore like Hockney's photographic drawing of his studio in Los Angeles, a sort of collage of old and new work, including real objects and people in combinations in which they were never actually seen. It looks quite like Courbet's bare Parisian premises, as described by his friend Jules Castagnary: 'In the corners there were huge rolls of canvas resembling carefully reefed sails. No luxury, not even ordinary comfort.' But it has become a place where the artist's visual imagination is at work (and play). This is one of the underlying themes of the artist's studio as a genre in art. It's the reason why Georges Braque chose his own as the subject of a series of works, the greatest of his old age. In these, each entitled simply *L'Atelier*, space becomes elastic, and the paintings merge into the place into which they are being made. Effectively, Braque was painting his own mental world, which comprised not just an approach to painting, but also a general philosophy. 'Everything', he declared later, 'is subject to metamorphosis,

everything changes according to circumstance. So when you ask me whether a particular form in one of my paintings depicts a woman's head, a fish, a vase, or a bird, or all four at once, I can't give you a categorical answer.'

As it happens, Braque was working for some of the time at Varengeville-sur-Mer on the Normandy coast, just to the north of La Grande Cour. Hockney mentions Picasso, the other co-founder of Cubism, much more often than Braque. But that quotation sounds quite like him talking, and so does Braque's remark to a fellow painter, Jean Bazaine: 'I am in the middle of my canvases like a gardener among his trees.'

*

DH They've modernized the house a little bit inside, but it's still higgledy-piggledy. J-P loves that word. Apparently, the French equivalent is not so good.

There are as many different types of assistant as there are studios – which means as many as there are artists. Some important painters work entirely on their own: just a person in a room with easel and paints. Others employ workforces large enough for a small factory. So artists' studios have differing populations – some are quite busy and social; and naturally the inhabitants of the place sometimes get into the works that are made there. Thus, in Hockney's *4 Blue Stools* from 2014, a digitally drawn fantasy derived from photographs taken in his Los Angeles studio, Jonathan Wilkinson and J-P both make an appearance (in Jonathan's case twice), as does Jonathan Mills, another member of the LA team, and other friends and acquaintances. In recent years, Hockney has repeatedly portrayed J-P and Jonathan in various media, just as Lucian Freud painted and etched David Dawson time after time.

4 Blue Stools, 2014

Lucian Freud, *Eli and David*, 2005–6

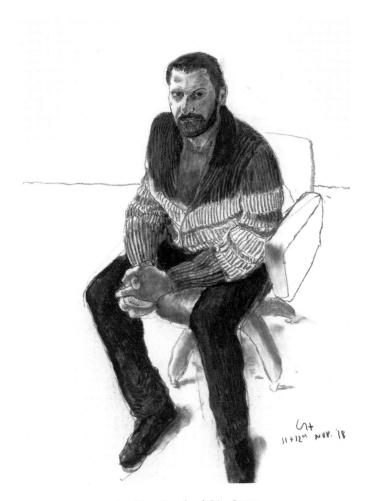

Jean-Pierre Gonçalves de Lima I, 2018

Assistants, like the rooms in which they work, form a subject in themselves, a subgenre of art. One of the greatest of all portraits, for example, is Velázquez's picture of his assistant Juan de Pareja. This suggests the closeness of the bond that can exist between people working, and often living, side by side in and around a studio. In Renaissance Venice, making art was often a family business: Tintoretto, for instance, worked among others with his son Domenico and his daughter Marietta. The habitués of Andy Warhol's Factory formed a miniature social and countercultural world within 1960s New York in which some helped to make pictures, others starred in films, and some simply hung out. Thus, what assistants actually do in any given studio is highly variable. In some cases, they physically make the work, as happened in the past in Rubens's massive atelier in Antwerp. This is the way Koons, for instance, operates now. Others, like J-P and Jonathan, facilitate in practical ways without ever picking up a brush or a piece of charcoal.

But they, and the other people who surround Hockney, also do more than that; they create a social and emotional support system, a bubble in which he can live and function. It is noticeable that instead of 'I', he often uses 'we' when talking. This habit reminds me of a star jazz trumpeter I knew who always announced what 'we' would play next, and thanked the audience for coming to see 'us', even when he was playing with a local rhythm section. Like him, Hockney tends to think in terms of the band.

That was also how Michelangelo lived. He always had assistants who carried out certain jobs for the master – such as preparing the plaster surface for fresco painting – but they also formed a close circle around him, an all-male substitute family. Michelangelo travelled with them, lived with them, fretted when they fell ill, grieved over them when they died.

DH I might have enjoyed Michelangelo's world. Many artists have assistants who are important to them. Leonardo had Salai. He stole from his master, but Leonardo forgave him. Salai was the equivalent of Mo McDermott for me. Mo did things like that, and I forgave *him*.

McDermott was Hockney's longest-serving assistant, on and off from 1962 until 1988, when he died (of drink). He was himself an artist, but his role was perhaps as much in the area of what Freud used to call 'morale'. Assistants can often be as crucial emotionally and psychologically as they are practically.

DH Mo was full of malapropisms and amusing sayings. When I was working on the portrait of Sir David Webster for Covent Garden, the only commissioned portrait I've ever done, Mo used to call it 'Sir Tulip Booth'. He worked that out because he remembered it was something to do with 'Webster', and there was a singer in the 1950s called Webster Booth. He was a tenor and sang with a soprano called Anne Ziegler: Anne Ziegler and Webster Booth. And there was a vase of tulips on the table in front of the sitter. So Mo called the painting 'Sir Tulip Booth', which I rather liked. I thought in some of those pictures by Lucian of David Dawson, Lucian actually told you that he loved David. With the women, it's not necessarily so; with them, he could be cold and aloof. But with David, he couldn't help it. David was doing everything for him at the end. I'm sure he encouraged Lucian. I have J-P, and he *encourages* me as well. And every day he makes me laugh.

No. 421, 9 July 2020

3

La vie française:
French life in the Bohemian style

Late in the afternoon, Jonathan drove me a mile or two down
the lane to a farmhouse bed and breakfast where Hockney's
visitors usually stay. After settling in, I came back about 7.30pm
for dinner, which turned to be a high-protein affair sourced
by Jonathan from the local shops. The result was Gallic, with a
no-nonsense Yorkshire touch and a distinctly masculine choice
of food. It consisted of an enormous crab in its shell, a large
slab of pâté, an abundant parcel of ham, bread, and butter, and
a bottle of wine. We dined at a table outside the house, beside
the pond. There were no sounds apart from an occasional frog
croaking or cricket chirping.

While we ate and drank, the conversation turned to travel
and the disadvantages of constantly shifting from place to place.
There is a dilemma here: the process of moving is exhausting
and often tedious, but the experiences to be had at the destina-
tion may be exhilarating.

DH I'm taking Rembrandt's advice: do not travel, not
 even to Italy. In Los Angeles now, there are too many
 interruptions for me. And it's an eleven-hour flight
 to get there. I don't want to do that too much. I've found
 a place here I really love.

I described a remark that I had heard an American jazz pianist
called Dick Wellstood, whom I greatly admired, once make.

After a wonderful performance, he announced in his strong
New York accent, like a character straight out of *The Sopranos*:
'Duh music is free; I charge fuh da travellin.'

DH [laughing] That's an artist speaking! It's a very good
 attitude. Look, a rabbit! [A thin agile creature quite
 different from a plump British rabbit loped past.]

David seemed to have guessed Dick's whole personality from
this single statement, like a palaeontologist reconstructing a
dinosaur from one bone. Of course, Hockney himself used to be
like Turner, an artist who travelled widely (unlike Constable,
who preferred to stay at home and paint familiar places). In the
past, he has visited and made pictures of China, Japan, Lebanon,
Egypt, Norway, and the American West. And at different times
in his long career, he has settled and worked in Bradford,
London, Bridlington, and Los Angeles, plus, of course, France.
It is sometimes forgotten that he was based in Paris in the mid-
1970s, so this is in fact his *second* French period.

MG Are you an English artist, American artist, or perhaps
 these days a French artist?

DH If you ask me where I live, I'd always say it's wherever
 I happen to be. I'm an English Los Angelino, now resident
 in France. And I'm going to show the French how to paint
 Normandy!

MG Now you are working in the countryside, like Monet or
 Pissarro, but your first French studio was in Paris.

DH Yes, I lived right in the centre of the city from 1973
 to 1975. I stayed in Tony Richardson's apartment in the

Balthus, *Le Passage du Commerce-Saint-André*, 1952–4

> Cour de Rohan, which was a little courtyard parallel
> to that funny old street, the Rue de l'Ancienne Comédie,
> and just a hundred yards from Boulevard Saint-Germain.
> When you looked out of the windows, it was just like
> a village.

The Cour de Rohan is one of the surviving parts of the old city, so much of which has been demolished. Parts of the walls built by King Philippe Auguste in the twelfth century still survive; other buildings were constructed on the orders of Henri II in the sixteenth century. It didn't just look like a village; the surrounding ancient heart of Paris was compact enough to live in as you might in a small community. Hockney got in the habit of walking everywhere: to the Louvre and other museums, to the cafés and restaurants. He didn't need to take taxis.

La vie française: French life in the Bohemian style

In his journals, Stephen Spender, a friend of David's and his companion on a journey to China in 1981, described his visit to Paris in March 1975. When he arrived, he took a taxi to the statue of Georges Danton on the Boulevard Saint-Germain, which was the landmark that Hockney instructed his guests to look out for: 'Just go past it', he would say, 'and you'll find me.' His studio apartment, Spender noted, was in 'a little courtyard where Balthus lived'. As they walked one evening to the brasserie La Coupole, Hockney pointed out a view 'exactly as it is in a Balthus painting'. Balthus (Balthasar Klossowski de Rola) lived and worked at 3 Cour de Rohan from 1935 onwards. He painted *Le Passage du Commerce-Saint-André* between 1952 and 1954, only two decades before Hockney arrived. The courtyard opens onto this little thoroughfare, which connects Boulevard Saint-Germain with Rue Saint-André-des-Arts. It was precisely the route that Hockney and Spender would have taken on their walk to dinner. He was living in the heart of old Bohemian Paris. Courbet's studio had been nearby, on Rue Hautefeuille, the small street where Charles Baudelaire was born; Delacroix's was on Place Furstenberg, of which Hockney made a photocollage in the 1980s, as was Monet and Bazille's; Picasso's was also close, on Rue des Grands-Augustins.

By the 1970s, the great days were in the past, but only in the quite recent past. At first, Hockney thought the old Bohemian Paris was entirely gone, but then he realized that he was probably living through the last bit of it. Giacometti had died in 1966; Picasso had moved to the south of France a few decades before, dying there. But Hockney was leading an existence much like theirs had been. His daily schedule consisted of breakfast at the Café de Flore, then back to the apartment to paint until lunch, which was eaten in one of the 'little places around', then working again until five or six, then off once again to the Flore or Les Deux Magots.

Place Furstenberg, Paris, August 7, 8, 9, 1985, 1985

DH It was wonderful, because for two years I just went to
cafés. I liked that life because you'd meet all your friends in
those places, so I could just get up and go home whenever
I wanted. But in the last year, people started to visit me:
Americans, French, English. They'd arrive at three o'clock
and stay until midnight. But I had only the one room, in
which I painted. It got so bad; it was almost every day.
In the end, I just packed up and went back to London.

Characteristically, where many might see only the picturesque
aspects of *la vie de bohème*, Hockney notices the inner discipline
of that way of life: an element that must have been essential since
these Bohemians were driven and hugely productive people.

DH Picasso would go to the Deux Magots and the Flore most
evenings in the 1930s. His studio was a few minutes away.

But he always left at ten to eleven, and he'd be in bed by eleven. He would never drink much alcohol – a bit strange for a Spaniard that. I think he *must* have had a routine, because he worked every day of his life, just as I do.

MG Actually, your daily timetable doesn't sound all that different now, forty years later, minus the trips to the Louvre and the cafés.

DH Well, there have been some changes. These days, I usually go to bed about 9.30pm. Most evenings, we go to this little restaurant in the nearest village, called Beuvron-en-Auge,

Beuvron-en-Auge Panorama, 2019

one of the prettiest in France. It's a workman's café really. For fourteen euros we get a four-course meal. There's tripe every day. I eat tripe *à la mode de Caen*, cooked in cider and calvados, and andouillette, tripe sausages – I'm always eating them. In fact, I'm eating better than I do in LA. I'm also breathing a lot better, so I feel a lot better. And I think I'm in a paradise, so what's wrong with that?

It emerged as we talked that Hockney had discovered opera, classical music, and the gilded gutter glamour of Paris all at the same time, one evening in Yorkshire a few years after the Second World War.

DH In the late 1940s, the music hall was still very popular.
My father used to take us to the Bradford Alhambra every
Saturday night. It was normally just one act followed
by another – a comedian or an acrobat perhaps – and a
number was displayed to show who they were. Usually,
the orchestra consisted of only five people. But when the
Carl Rosa Opera Company came to town with *La Bohème*,
it was around twenty strong. We looked down from the
balcony at the top – we stood for sixpence – and could
count exactly how many players there were. I realized
then, even though I was only about eleven or twelve, that
it was better music. My father said, 'Oh, some nights it's
like that.' He didn't care very much for it, though, because
there weren't any jugglers or acrobats. That's what he
liked to see – and that's what the music hall had: all kinds
of acts, not just the stars. It was twice nightly, at six
o'clock and eight thirty, for years. It went on until I was
about fifteen. Then it faded out because of television.

 La Bohème was the first opera that I saw. I've checked:
it was on in Bradford about 1949. What I could tell was
that it was about artists in Paris. I didn't know anything
about the music then, but I *liked* it.

MG That old-style Parisian Bohemia might have looked
casual and laid back, but a lot of art, literature, and new
ideas were worked out around those café tables from
the nineteenth century to the middle of the twentieth.
Impressionists, Surrealists, and Cubists sat and talked
in those places, but also half the great writers of the age:
James Joyce, Ernest Hemingway, Gertrude Stein, F. Scott
Fitzgerald. You could think of Bohemia as more of a
think tank than a rabble of drinkers and party-goers. And
a great deal of what those artists accomplished came down

to viewing life, language, and the world from a fresh angle: just as the paintings of Braque and Picasso depicted the jumble of glasses, bottles, pipes, and newspapers on those very tables, but seen in a dizzyingly radical new fashion.

DH Yes! Isn't that what you need: people who can see things from different points of view? For most of my life there was a city called Leningrad; now it's called St Petersburg. Leningrad, it turned out, was just a blip, but we all thought it was here to stay. That's why I was always against communism: people telling you that you should sacrifice the present for the future because it's going to be terrific. But how do they *know* it's going to be terrific? Nobody knows. You have to live in the here and now. It's the now that's eternal. The fact that no political-science department of any American university predicted the fall of communism tells you that they were employing conformists, not oddballs. Well, you need a few oddballs. That's why you need lots of artists, and not just painters but all kinds. They look at life from another angle.

In the past, non-conformists could survive very well in England and America. The thing about Bohemia was that everybody knew that you had to have money to lubricate life, but it wasn't that you would go chasing it. Bohemians rather looked down on that kind of thing. That's the Bohemia I knew in New York – in the East Village – and in Los Angeles, and it was a view of life I liked. But those really cheap places don't exist any more. Manhattan is now too expensive for most artists. Bohemia has gone. When I first went there, I'd stay on Ninth Street. The moment I arrived, they'd say to me, 'You must see this show, you must see that show!' And I did, and they were always exciting. I'd go to the theatre of the absurd in

Greenwich Village. But it's all gone. There's nothing like Studio 54. Money has taken over. If the young can't move in, cities die. That's what happened to Paris: it got too expensive. In the great days, the young could move there from the provinces. There's still maybe a bit of a Bohemia in LA. Young people do go there. These days no one can just turn up in Manhattan and live there, but if you come to LA, you can get a house and a car. Young painters are going there – rather good ones, some of them.

<div align="center">*</div>

Part of Hockney's motivation for moving to Paris in 1973 was the same as his reason for spending so much time in the United States in the 1960s, for eventually migrating to Los Angeles, and for his move to Normandy now: he has always found his homeland constraining and frustrating.

DH Boring old England. You can't do this, you can't do that.
That's why I went to California all those years ago.
I always thought there was so much self-hatred at home,
and so many mean spirits. Well the mean spirits have
really come out again now, it seems to me!

When he said this, I pointed out that he has been saying the same thing for nearly fifty years. If his approach to art is remarkably flexible, his views on some subjects – such as the petty, killjoy attitude of the English – are remarkably consistent. While researching for my book *Modernists and Mavericks*, I discovered that he had made almost precisely the same complaint to Atticus of the *Sunday Times* in January 1966: 'Life should be more exciting, but all they have [in London] is regulations stopping you from doing anything. I used to think

London was exciting. It is, compared to Bradford. But compared with New York or San Francisco, it's nothing. I'm going in April.' While walking through the Parisian twilight in 1975, he had made a similar series of complaints to Spender, as the older man recorded in his diary: 'En route David said he greatly preferred Paris to London, that London was dull and lifeless, nothing was open after midnight, in order to enjoy yourself you had to spend a great deal of money in expensive nightclubs – there were no cafes etc.' There is a paradox here. Hockney chafes at the puritanical constraints of British life, but when he escapes from them, he immediately sets up a way of living that almost everybody else would find daunting: drawing, painting, working, day after day after day. The painter Frank Auerbach once wryly noted the same was true of his own unbending and unending daily programme:

'Nobody goes into art because they say to themselves, "Oh my God, I don't think I could stand the freedom of working in bank or an office. Let's go into art because at least there'll be a set timetable and I'll know what I'm doing every day." I thought this would be a sort of freedom; I couldn't face the idea of being an employee in a job. But the freedom and the excitement of the activity has forced me into a far more rigid, seven-day week than I would have been in if I had gone into something more sensible. If I had become a lawyer, think of the variations and the excitements there would be!'

The lives of creative people may seem chaotic, and their surroundings may indeed be untidy. But, as Tim Harford argues in his book *Messy*, there are advantages in 'the untidy, unquantified, crude, cluttered, uncoordinated, improvised, imperfect, incoherent, random, ambiguous, vague, difficult, diverse or

even dirty'. Those are the circumstances in which insights are found and discoveries can be made. Perhaps that is why Picasso proclaimed, 'I don't search, I find.' If everything you do is carefully controlled and pre-planned, that is less likely to happen. Hockney likes to quote the seventeenth-century poet Robert Herrick's *Delight in Disorder*: 'A careless shoe-string, in whose tie / I see a wild civility: / Do more bewitch me, than when art / Is too precise in every part.' On the other hand, you won't find a lot unless you're looking all the time, and you won't do much with what you do find unless you have energy, skills, and determination.

Among the things that Hockney was searching for in Paris was technique. As he walked over to La Coupole with Spender in 1975, he also denounced the deskilling that was then taking place in British education: he 'talked rather angrily about the state of art in England.... At some art school he had visited, whoever showed him round said, "In this room the students do what they want" as though it were a kindergarten.' Spender noted that Hockney now 'dared to say he hated modern art'. But it would be more accurate to say that he was enraged by some of the tendencies in what was then *contemporary* art, in particular the disappearance of the expertise of the hand, what he later dubbed 'the craft of painting' when one day we were looking at Jan Vermeer's masterpiece *The Art of Painting*.

During his time in Paris, Hockney was in fact looking intensely hard at the great figures of early *modernist* art, above all Picasso. But he also lingered in the sculptor Constantin Brancusi's studio, then preserved at the Museé d'Art Moderne, and next door to a room of Julio González sculptures, which Hockney had always loved and had made two paintings of in 1972 before he had even moved to Paris. He also began to develop an eye for what might be called the handwriting of French artists – the way they drew and used the brush, the

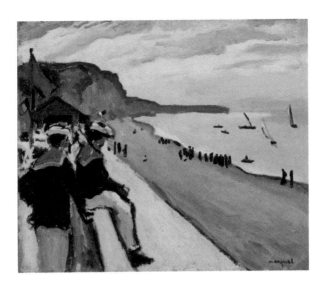

Albert Marquet, *The Beach at Fécamp*, 1906

marks they made on paper and canvas – including figures who were far from being considered heroes of modernism, indeed half-forgotten outside France, such as Albert Marquet, a lesser-known member of the Fauvist group. In 1977, shortly after the end of his first French sojourn, Hockney told the critic Peter Fuller about an exhibition by Marquet that he had seen at the Musée de l'Orangerie in the Jardin des Tuileries just before his impulsive departure from Paris in November 1975.

'I'd always thought of him as a rather minor artist till then. But I was thrilled by the exhibition: my enjoyment was enormous. He had an uncanny knack of looking at something, simplifying it almost to one colour, and being able to put it down. The reality of it was so great that at times I thought, it's more real than any photograph I've ever seen.'

Stage study from 'Les Mamelles de Tirésias', 1980

There, in that chance visit to an exhibition, lay the germ for decades of thought and work: how the stroke of a brush, pen, or stick of charcoal could produce a picture that was better and in a way truer than any camera. What he saw in Marquet's work was what he also finds in Monet: beautiful marks that reveal the beauty of the world, so that when you've seen their pictures you see more in the world around you. Of course, that's what he is doing himself. 'It was a very, very vivid experience to me', he told Fuller. 'To be able to walk into the street and to see in the most ordinary little things, even a shadow, something that gives you this aesthetic thrill is marvellous. It enriches life.'

A few years later, in 1979, he embarked on a series of stage designs for a triple bill of early twentieth-century French pieces at the Metropolitan Opera in New York: Erik Satie's ballet *Parade* and two short operas, Francis Poulenc's *Les Mamelles de Tirésias* and *L'Enfant et les sortilèges* by Maurice Ravel. In preparation, he listened to records of the music, and as he did so the memory of that French painterly calligraphy came back, as he explained in his 1993 memoir *That's The Way I See It.*

'I thought the one thing the French were marvellous at, the great French painters, was making beautiful marks: Picasso can't make a bad mark, Dufy makes beautiful marks, Matisse makes beautiful marks. So I did a number of drawings using brushes, letting my arm flow free, exploring ways of bringing together French painting and music.'

Around this time, he talked about 'French marks', free-flowing and elegantly attractive in themselves. His mention of Raoul Dufy – like his appreciation of Marquet – is characteristic. These two artists were among several from the so-called School of Paris whose reputations have dwindled. They are widely regarded as too gentle, too soft, above all too decorative. This is a line of criticism from which not even Matisse is immune.

Raoul Dufy, *Les Régates*, 1907–8

But Hockney, like Walter Gropius, founding director of the Bauhaus, believes that pleasure is a requirement for art. He deplores the puritanical attitude of the art world to enjoyment as much as he does the bossiness of the English.

DH I was in San Francisco once, and a curator said to me that he *hated* Renoir. I was shocked by that. I said, 'What word would you use to describe your feelings for *Hitler* then?' Poor old Renoir. He hadn't done anything terrible: he'd painted some pictures that pleased a lot of people. It's awful to say you hate him for doing it!

The Louvre, ten minutes' walk away, was one of his habitual destinations. It is a huge museum that takes many visits to get to know well, which was what he had the opportunity to do. On one occasion, he had what James Joyce called an 'epiphany', a moment of sudden revelation, as he described in his earlier memoir, *David Hockney by David Hockney*, published in 1976:

'In the Pavillon de Flore, they had an exhibition of French drawings from the Metropolitan Museum, which I thought was a really beautiful show. I went to see it a few times. The first time I went, I saw this window with the blind pulled down and the formal garden beyond. I thought, oh, it's marvellous, marvellous! This is a picture in itself. And then I thought, it's a wonderful subject and it's very French; here I am in Paris, I've abandoned some other pictures, why don't I do that?'

The result was a painting entitled *Contre-jour in the French Style – Against the Day dans le style français*. He admitted to being pleased with that title, with its witty mingling of two languages and the notion of something Gallic done by someone English.

Contre-jour in the French Style – Against the Day dans le style français, 1974

As indeed he was happy with the work. He had consciously decided to use a French manner, pointillism, so this in a way was an earlier investigation of the wonderful world of French marks. There was, he reflected, a 'perversity' about using such a technique then, in the 1970s, and especially for a subject in Paris, which had been a staple theme for great painters since the days of Édouard Manet at least. He was prepared to risk that standard of comparison, as he wrote at the time:

'Paris has been painted by so many people; by very talented artists, much greater than I am. I want to take up the challenge, because it's worth the trouble and I like to make life difficult for myself. If you want to paint anything worthwhile you shouldn't be afraid of stepping up the pressure. That suits me, I'll stay.'

The moment when he saw that half-obscured window in the Pavillon de Flore and decided to make a picture – in fact, more than one since there was a painted version and a virtuoso ten-colour etching too – Hockney was choosing a path. One consequence was that windows, almost always contre-jour – or against the light of day (though occasionally turned into black mirrors by darkness outside) – became a favourite motif, indeed, eventually an entire subsection of his work. A window is just automatically a picture in itself, a view onto the world, and it is one that compresses epigrammatically many of the ingredients of naturalistic art. A window juxtaposes near and far, light and darkness, shadow and reflection. The pictures that Hockney made of and through his bedroom window in Bridlington added up to a complete and beautiful book in themselves. And he has carried on in Normandy: another of a little old pane of glass on a rainy day arrived while I was writing this chapter. It too makes you think, 'Oh, it's marvellous!'

During these years, Hockney was moving along a trajectory that steadily diverted from the route that many of his contemporaries were taking. For them, the most influential figure from the recent past was Marcel Duchamp. Forgotten for much his lifetime, Duchamp had turned into a towering figure in contemporary art. His ideas – which came down to the assertion that art itself was an idea, and it was the artist's thought that counted – underlay much that was happening in the 1970s: land art, installation art, conceptual art. Hockney would not disagree with the proposition that what a painter does is sometimes intellectual, even metaphysical.

DH Duchamp played very interesting, enjoyable games, but
a school of Duchamp is a bit un-Duchampian, isn't it?
He would laugh at it. Art comes in all kinds of forms.
It isn't just drawing and painting. The great movies are
great works of art. Some things I'm a bit indifferent to,
but I enjoyed Duchamp's games. You can have art without
an object – it's called music and poetry – and it's not new.
I think we need all kinds of artists. And that's what we
normally get, so I would on the whole support any artist,
but some I would rush to see more than others.

Duchamp, who was neither prolific not particularly gifted as a painter, despised what he called 'retinal' painting that appeals to sensual, visual experience. Hockney was obviously going in the opposite direction. He was doing what perhaps all strongly individual artists do: choosing a tradition to join. French art had always been one of the elements in his background. His early works done at the Royal College of Art owed a good deal to Jean Dubuffet and his *art brut*, which drew on graffiti and what is now called 'outsider art'. It was an antidote to the gentility of most work done in 1950s Paris (and London).

DH Nothing much has happened in French painting
 since Dubuffet. He was the last really good painter here.
 In the 1950s in Paris, they all did what people called
 '*belle peinture*', but that was meant as a put-down.

While his embrace of Dubuffet was a passing phase, Picasso
turned out to be one of the artistic loves of his life. He regretted
never having had a chance to meet his idol. Picasso's death was
announced on 8 April 1973, just as Hockney was setting out
on a journey to France, and shortly before he settled there.
Nonetheless, the Spaniard became his chosen teacher, the
master instructor that he had never really had at art school. In
Paris, working with the printmaker Aldo Crommelynck, who
had himself worked with Picasso, he made two commemorative
prints. One was entitled *The Student: Homage to Picasso* and
showed Hockney wearing his fashionably flared trousers,
holding a portfolio, and standing in front of a bust of Picasso
on a plinth. The other was called *Artist and Model* and showed
an imaginary meeting between the two at a table in front of
another window in the French style. Hockney is naked, so is
presumably the model, but of course he is actually the draughts-
man drawing the lines, so it is possible to take the title in an
opposite sense. From now on, Picasso became *his* model.

DH In Paris, I always go to the Picasso Museum, because it's
 very dense. It's full of things, and there's always something
 I've never quite seen before. An artist that good doesn't
 really go on repeating themselves in old age; they are
 forever doing something new. Late Picasso is fantastic!
 He is still influencing me.

MG I suppose an artist or any person who continues to grow
 is like a tree or any living thing. A plant takes in water,

The Student: Homage to Picasso, 1973

minerals, light, and carbon dioxide and transforms them into leaves and flowers. In the same way, people who continue to blossom also need to carry on processing fresh thoughts and experiences.

We talked on and on in the warm French evening. After a while, the moon rose over the half-timbered studio. Before I left for the night, mindful that I should not disrupt his working routine, I asked what time I should come around the following morning. After breakfast, say nine o'clock? There was a pause. Then David replied, 'Hmmm, maybe half past nine.' I took it that he wanted to work for a while after he woke up and, he explained, that might be quite early.

DH I've been back from LA just over a week, and I haven't quite got the jetlag out of my system. I go to bed at nine or ten, but I don't fall asleep until two or three. If I get a bit tired during the day, I just go to bed. This morning I did. I was up at six, working. Then I went back to bed at ten and slept until twelve.

It was time for me to go back to the farmhouse where I was staying and sleep, surrounded by fields, trees, and – except for an occasional cow – silence.

No. 507, 10 September 2020

4

Lines and time

I took the hint and the following day walked over from the farm where I was staying after a late breakfast. The morning was fine, and halfway there I met Jonathan driving down the lane to get some supplies, which reassured me that I was heading in the right direction. It must have been nearly ten o'clock by the time I arrived at La Grande Cour, where everything was utterly tranquil. After looking around, eventually I found Hockney quietly at work at the dining table inside the house. The room, a long, low, dark-beamed space, was full of bouquets of flowers sent to mark his eighty-second birthday a few days before. He was busy on his current landscape, drawn on a sketchbook consisting of a single sheet of paper that opened out like a concertina. For a while, I watched him slowly adding the dots that represented the gravel path around the house.

Work, to him, is a pleasure, and also a habit. When he moved into his flat on Powis Terrace in 1962, the largest room served as both his bedroom and his studio. On the chest of drawers, he placed a notice in large capital letters reading 'GET UP AND WORK IMMEDIATELY' (which he did with all the more alacrity since he regretted wasting two hours painting the sign). Nearly sixty years later, his sense of urgency has, if anything, increased. He told the *Wall Street Journal* that one of the charms of La Grande Cour was that it enhanced his productivity: 'I can do twice as much work there, three times as much, I've probably not much time left and because I don't, I value it even more.' Old age, and how to live it best, are understandably questions on his mind these days.

La Grande Cour Living Room, 2019 (detail)

Autour de la Maison, Printemps, 2019

DH I know I'm eighty-two, but I feel thirty in the studio when I get going. I stand up to paint. I stand up to work, mostly. Sitting down is supposed to be bad for you, but everything is supposed to be bad for you. I just ignore it. My mother lived to be ninety-eight. You have to be very tough to live that long. I remember telling her over the tea table that Diana, the Princess of Wales, had been killed in a car accident. She said, 'That's very sad!' Then she said, 'Do you think there's another cup in that pot?' Fate has not been cancelled, has it?

After a while, he paused for a break and, slightly alarmingly, pulled out the concertina to its full length and handed over what he had been doing for me to take a closer look. This made me a little anxious since I am the sort of person who, confronted

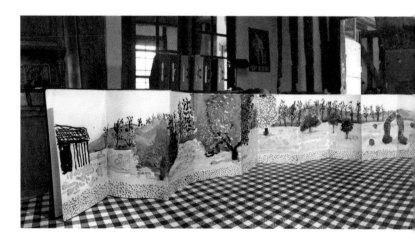

with a map, will always refold it the wrong way round. So after having admired this almost finished drawing, I carefully handed it back to him to tuck into the correct order.

DH These dots take a while. I'm using a reed pen to make them. There's a particular line you get from a reed pen. Everything makes a different sort of line. And I've always enjoyed making different *kinds* of lines. I happen to like drawing. I draw all the time. Wasn't it Degas who said, 'I'm just a man who likes to draw.' That's me, I'm just a man who likes to draw. I think an awful lot of people like to draw. I'm always meeting people who draw a bit crudely, and I point out that what's needed is a bit of practice. You need things pointed out to you: how to see in a clearer way. You can teach the craft; the poetry, you can't teach.

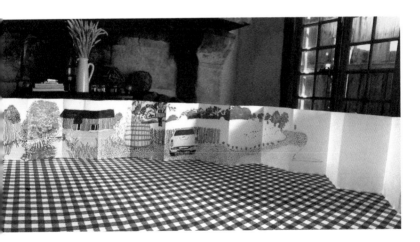

Autour de la Maison, Printemps, work in progress, July 2019

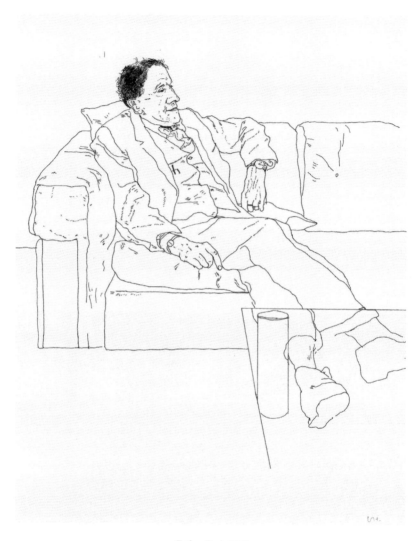

Father, Paris, 1972

Mother, Bradford. 19th February 1979, 1979

He has indeed made many different kinds of lines. An art historian could put together a chronology of his career just in terms of the multiplicity of diverse lines that he has produced. In the late 1960s and early 1970s, for example, there were the ultra-thin marks made by a kind of pen called a Rapidograph, with which he created drawings modelled with line alone – no shadows. Then, quite different, the works in coloured crayon and pencil of the early 1970s; the chunkier reed-pen strokes of portraits from the end of the decade, such as the poignant one of his mother done just after his father died in February 1979 (not 1978, the date inscribed on the drawing); the later ones drawn with a brush, including watercolours from 2003; the extraordinary charcoal landscapes of the *Arrival of Spring 2013*;

and on and on. Each of these graphic media, he likes to say, sets its own technical tests for the artist. The Rapidograph required extreme concentration, because there was no possibility of erasure and correction. With charcoal, changes are much easier, but, he points out, you can't put your hand on the drawing because it will smudge. Watercolour is equally unforgiving in another way: put too many layers on top of each other and it will go muddy. Conversely, each of these methods presents unique possibilities. The almost miraculous evocation of light, shadow, and reflection in those charcoal views of puddles and burgeoning vegetation along the East Yorkshire road called Woldgate (*see page 257*) could not have been achieved with a Rapidograph; nor could the Grecian elegance of his Rapidograph works have been accomplished with charcoal or crayon. He is a connoisseur of effects that can be obtained with various kinds of line, sometimes in unexpected places.

DH There's a wonderful drawing by Klimt in the Lauder Museum in New York [the Neue Galerie], a nude. The way it was drawn with red and blue lines weaving around each other … I've never forgotten it. I thought it was incredibly good. It not only made the contour soft, it made it *shimmer*. I'd never seen that, not even in Picasso. It gave you a lot of information: you can see she's got soft skin.

When I looked up this drawing, it turned out to be strikingly erotic, a point that Hockney – typically – hadn't even men-tioned. This is an example of his utterly matter-of-fact attitude to sex and sexuality, as something so natural as not to be worth remarking on. The way that Klimt had interwoven those col-oured lines must have struck him – quite obviously if you are a passionately enthusiastic follower of graphic media – as the most sensational aspect of the picture.

Gustav Klimt, *Reclining Nude Facing Right*, 1912–13

Vincent van Gogh, *Harvest – The Plain of La Crau*, 1888

In Amsterdam in February 2019, where he was to install his show at the Van Gogh Museum, *The Joy of Nature*, he had felt a double recharge of linear inspiration, as he had been in close contact with two of his greatest idols among the draughtsmen of the past, Rembrandt van Rijn and Vincent van Gogh. There are obvious connections between his drawings of Normandy and theirs. Both Dutchmen used the same medium that he was employing – reed pen on paper – and there are affinities in the kinds of marks he was making. Those dots, for example, were a favourite graphic device of van Gogh's. But there were also fresh, and characteristic, Hockney ingredients: most of his panoramic drawings were in *coloured* inks.

Autour de la Maison, Hiver, 2019 (details)

Rembrandt van Rijn, *St Jerome Reading in a Landscape, c.* 1652

In the exhibition at the Van Gogh Museum, Hockney's work was hung beside his predecessor's. At the same time, over at the Rijksmuseum there was a grand show of all the works by Rembrandt held in that museum's comprehensive collection.

DH We saw the Rembrandt exhibition with nobody in it, and then we went again with Celia [Birtwell] when there was a crowd, which wasn't so good because you couldn't go backwards and forwards and *compare* things.

But in his studio, he had a giant volume of Rembrandt's *Complete Drawings and Etchings* placed for browsing. This meant that he could not only compare and contrast, but do so at greatly enlarged scale, something he believes only enhances the impact of these graphic works, in his opinion the finest ever created.

DH I think it's wonderful when they are bigger, because you can see more of the hand. Many of the originals are very small. That's because paper was expensive in 1650 when Rembrandt was making them, and the individual sheets weren't necessarily that big in any case.

The implication is that, had Rembrandt had the facilities in his studio for enlarging his works that Hockney has, he would have used them with delight. Hockney himself has taken to doing so in recent years, with his own work and other people's too, including that of old masters. Fellow artists who worked many centuries ago continue to be active sources of ideas for him. As he says, if a picture is still exciting and interesting you, it's still contemporary. It will have an effect on you now. The previous October, he had travelled to Vienna to see the exhibition of Pieter Bruegel the Elder at the Kunsthistorisches Museum. He spent several days there, doing nothing but looking at Bruegel.

DH Bruegel's pictorial space is better than anybody's.
The *Conversion of Paul*, for example, is amazing. When
you look at it, you come from way down the Alps and
are going up to the summit. I thought of doing something
similar. He must have drawn all the mountains on his
journeys through the Alps. Living in Flanders, there's not
even a hill. Mind you, in 1550, when he made the journey,
crossing the Alps was quite an operation, and then you'd
have to cross the Apennines. It would take a long time,
going up very slowly, right up and down. There were
only certain ancient passes you could use – like the Saint
Gotthard Pass – and there was always snow.

Pieter Bruegel the Elder, *Conversion of Paul,* 1567

Pieter Bruegel the Elder, *Children's Games*, 1560

Hockney had Bruegel's *The Tower of Babel* blown up to about four metres high, much larger than the original, and he also enlarged the Flemish artist's *Children's Games* to a slightly smaller size. The latter was just visible behind a new Hockney watercolour of La Grande Cour in the new studio.

DH We just made *Children's Games* three metres high, because I said you are not looking up, as you do at the top of the Tower of Babel; you are looking *across* the scene. Now we have covered it up, because I want to look at that painting of mine of the house.

The works by van Gogh and Rembrandt that he had seen in Amsterdam, and also Bruegel's in Vienna, primed him for the new phase of work that he was keenly looking forward to

starting the moment he got into that new studio in Normandy. 'Bruegel, Rembrandt, and van Gogh all drew landscapes with great clarity, "extra crispy and clear"', a friend had said to him. Clarity is one of the great Hockney virtues; he likes things to be absolutely clear: speech, writing, pictures, ideas. He also values the closest possible observation of everything around him, including – as he explained to Jonathan Jones of the *Guardian* – bad weather (although strictly speaking he thinks there is nothing of the sort).

DH [in emails to JJ] Ruskin said there was no such thing as bad weather in England. I remember being in Bridlington one winter evening when the weather forecast was on. They told us not to go out as there was going to be a terrible snowstorm. This made me sit up, and I suggested that we go out to see it. We got in our four-wheel-drive truck and drove slowly to Woldgate, not very far. We only went up it about half a mile, and then we stopped. The headlights from the car lit up the snow very dramatically and we watched it forming on the tree branches. It was magical, I thought, really memorable.

One of the Bruegel works that had caught his eye, and mine, because of its almost uncanny evocation of what it is like to walk through a blizzard of thick soft snow was a little panel from the Oskar Reinhart Collection in Winterthur, Switzerland: *The Adoration of the Kings in the Snow* from 1563.

DH That painting of a snowstorm is just *like* snow! Where the snow is coming down in those places where it's dark, you see the falling flakes, and where it's light, you don't. That's just like in real life. Bruegel's observation of the snowstorm was *perfect*.

Pieter Bruegel the Elder, *The Adoration of the Kings in the Snow*, 1563 (detail)

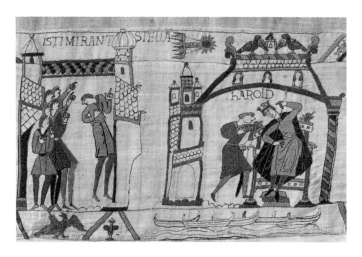

Scenes from the Bayeux Tapestry, 11th century, showing men staring at Halley's Comet (left) and King Harold in his palace at Westminster (right)

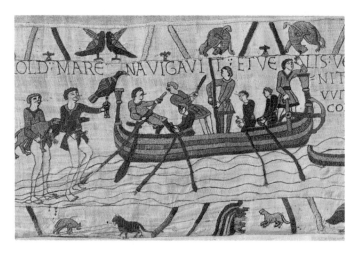

The embarkation of the Anglo-Saxon aristocrats across the English Channel

There was another, unexpected precedent in his mind as he set to work at La Grande Cour; not a painting, but a master-piece of medieval needlework. Hockney's appetite for pictorial space – wider and wider vistas, in all directions, up and down and side to side – is insatiable. It was one of the qualities that had attracted him to the Bayeux Tapestry, which was in turn among the sights that had drawn him back to Normandy in 2018, and hence triggered this whole new phase of his life and work. He had seen it once before in 1967, and then again – twice – forty-two years later. Here is a demonstration of the truth that the most significant factors in an artist's life – perhaps in anyone's – are not easily accessible to conventional biography. They may be sights, sounds, impressions, or feelings: elusive and hard to put into words. In this case, the memory of an ancient piece of embroidered cloth, seen half a lifetime ago, had helped – how much it is hard to say – to set Hockney on a fresh course in a new place. Now he had settled at La Grande Cour some forty minutes' drive away from Bayeux. Before he even started working there, he mused to Rachel Campbell-Johnston of *The Times* on how he intended to depict spring in Normandy 'like the Bayeux Tapestry, as a long, long thing'. He went on: 'I am not quite sure how yet. I'll probably begin with small paint-ings. But I may move on to my iPad or to film. I don't yet know.'

Famously, he likes 'bigger pictures', by which he partly means ones that are not confined by tight boundaries.

DH I hate white walls behind paintings; they make you see
the edges too much. When I was one of the organizers
of the Royal Academy Summer Exhibition, the first thing
I said was, 'Don't paint the walls white!' Previously, they
had done that, so it always looked like a jumble sale
– whereas if you tone that down by adding a bit of colour,
the edges are softened.

The attraction of the Tapestry for Hockney is that it is a picture almost seventy metres long and half a metre high (and more than nine hundred years old) that lacks exactly what he has long yearned to escape: those neat edges that confine the conventional rectangular picture frame. He points out that at the bottom is the ground, the top is the sky, and, as you walk along from one end to the other, two years of time pass. In these respects, it is like another type of work that has long fascinated him, the Chinese scroll, which also unwinds through space and time, with never a fixed vanishing point. In its way, too, the Bayeux Tapestry is rich in carefully observed, visual information (which is just as much evidence as the written kind). As Carola Hicks notes in her book on the subject, by looking at the Tapestry you can discover intimate things about eleventh-century life: how Anglo-Saxon aristocrats embarked to cross the English Channel; 'how a horse clambers out of a ship'; or how two servants, with 'hose removed and tunics rolled up', wade barefoot through the waves and carry their precious hunting animals, hounds and a hawk, on board.

The Bayeux Tapestry is an outlier, in terms of survival. Originally, there might have been hundreds of such narrative textiles hanging on the walls of Romanesque strongholds (this one, Hicks suggests, was perhaps intended to hang around the walls of William the Conqueror's great hall in Rouen). But it is now the only such Romanesque textile that remains, and it has left Bayeux Cathedral only once in four hundred years, for an exhibition in Paris at a time when Napoleon was planning an invasion of Britain, for which it seemed an encouraging precedent. Also, of course, it is a picture made entirely of thread – an embroidery, strictly speaking, rather than a tapestry – a medium that has long been marginalized in histories of art. Consequently, it does not often feature in those beside the works of Giotto and Raphael. I could not find Hicks's book in the art department of

my local bookshop, and had to ask an assistant, who tracked it down in the medieval-history section.

Hockney would argue that there is a deeper reason for that categorization as factual reportage rather than masterpiece of art. The Bayeux Tapestry represents the world in a way that has been regarded as 'primitive' or flatly 'wrong' in the Western artistic tradition since the Italian Renaissance. It has a different relationship to space and time. There is no fixed point for a single linear perspective to recede towards, no frozen moment. Instead, it flows backwards and forwards from England to Normandy, across the sea and through the unfolding events from 1064 to 1066. Hockney's panoramic concertina drawings of his garden are smaller in scope, both in territory and time, but they include several acres of ground spreading to all points of the compass, and the length in seconds, minutes, or hours that it takes to look hard at all that. He has shown enlarged versions of these drawings that unite multiple spatial and temporal experiences in a single image around the walls of a New York gallery; meanwhile the Tapestry itself makes a token appearance in his studio in the unexpected form of a set of cushions.

*

Visitors were expected at La Grande Cour for lunch, a group of old friends plus their guests. They were bringing all the food, so there was no need to get anything ready. Hockney is by no means averse to food, which – like all the pleasures of life – he enjoys, but he has reservations about the possibility of such meals eating into the time and concentration he has available for his studio work.

DH At one time, in the 1960s and early 1970s, I went to lunch quite a few times with Marguerite Littman, an American

living in Chester Square who entertained a lot. I used
to drive there and drive back to Powis Terrace, a bit
drunk actually. I stopped going because I realized that
if I didn't work until twelve and then went out to eat
like that, I didn't get anything done for the entire day.
So I stopped going. She asked why, and I explained,
'I want to work!' Most people who go out to lunch have
nothing to do in the afternoon. Or they sit at their desks,
not doing much. But I'm not like that.

Having got as far as he could with the drawing that morning,
he decided to prepare himself by stretching out full length on a
sofa, pulling his cap down over his face and drifting off to sleep.
While he had his nap, I wandered out to inspect his domain,
strolling over the meadow down to the boundary where a little
stream purled along with trees arching over it from either bank.
Then I followed the perimeter around to the gate and back up
to the house. It was a terrain that I was to see in every aspect in
hundreds of drawings in the months to come. I also imagined
that before too long, certainly the following year, I would be
back here in person, looking at these same trees and stream,
chatting with David, J-P, and Jonathan. But that was not to be.

No. 556, 19 October 2020

Christmas Cards, 2019

5

A merry Christmas
and an unexpected New Year

More months passed and more pictures were dispatched from La Grande Cour. By way of a thank you for Hockney's hospitality, I sent a parcel of books that I thought might appeal to him. Among them was *Travels with Epicurus* by Daniel Klein, an American writer reflecting on time and ageing while living on the tranquil Greek island of Hydra, where the petrol engine is banned. Klein, who is in his seventies, argues that, rather than trying to hang frantically and impossibly on to youth, we should value old age as an important phase of life in its own right: a time to reflect in peace. Hockney very much concurred.

DH *Travels with Epicurus* is really excellent. He smokes and
 drinks a lot of retsina. I know why they go on smoking
 in Greece: they know that time is elastic and there is
 only now – my attitude perfectly. I gave it to a friend,
 and he gave it to a twenty-five-year-old. But I think it's
 only a book for old people. The twenty-five-year-old
 wasn't that interested; after all, to someone of that age,
 a person of seventy-five is half a century older, and that's
 ancient. It's a long, long span of time.

His iPad-drawn Christmas greeting for 2019 was a riff on a favourite motif: pictures within pictures within pictures, in this case evoking a long vista of Christmases and New Years that stretched back into the past and forwards into the future.

Of course, although time and history stretch on and on, as well as back and back, the future is crammed with unexpected twists. Early in January 2020, without much warning, as I was about to have breakfast one morning, I had a heart attack. It was not a severe one; the diagnosis was almost more of a shock than the event itself. But still, it was a nasty jolt. It was comforting to discover that Hockney had been there before me.

Dear David
A week ago I had a heart attack. It wasn't a serious one, fortunately. They put a stent in the blocked artery straightaway and I was in hospital only for a couple of nights. I should be back to normal by early February, but for now I'm under instructions to rest, so I'm doing a lot of reading. In the cardiac ward, I read Ovid's *Metamorphoses*, which, apart from providing the subjects of innumerable paintings, has a little thesis: that everything is constantly changing. His characters are always being transformed into stones and trees, birds, and animals. It's not a bad metaphor for human affairs. Now I have been changed into a convalescent like someone from *The Magic Mountain*, and my old editor at the *Spectator*, Boris Johnson, has metamorphosed from a humorous journalist into prime minister. We'll see what happens next.
Love
Martin

Dear Martin
I had a small heart attack thirty years ago. They said it was from smoking, but I didn't think so. It was stress. I had stents put in too; I think they're very good. Since arriving here in LA, I have been at the dentist six times,

and then the doctors for a lot of scans. I am OK really, and I should be finished with them this week. We should be back in Normandy on 8 February, in time to paint the arrival of spring. It's good to rest and read. That's what I have been doing, although I did draw Maurice Payne and Benne Taschen (Benedikt's son). But on the whole I have been resting, which I needed, they tell me. All my love
David H

Hockney is not a believer in healthy living so much as in good living, which in his view means enjoying life in its fullest sense: experiencing all the beauty of the world around, and concentrating on a task that is completely absorbing. In that respect, he is in accord with the ancient Greek philosopher Epicurus (341–270 BC), who believed that the ideal existence was one devoted to enjoying life's pleasures, but held that the most enduring of those were simple. He spent his time talking, writing, and thinking in a garden outside Athens. He also held that life's pinnacle lay in old age. Like Epicurus's latter-day proponent, Klein, Hockney does not have much time for the 'ever-youngers' trying with a desperation that increases with age to hang on to a youthful body. He likes to quote a short comic poem by W. H. Auden, 'Give me a doctor', in which the speaker hopes for 'a doctor partridge-plump' who will never 'make absurd demands' that the patient give up his vices, 'But with a twinkle in his eye / Will tell me that I have to die.'

By the end of February, I was indeed feeling more or less back to normal, and I saw Hockney several times in London, where he was opening two exhibitions, one at the National Portrait Gallery and another – of his new portrait cycle – at Annely Juda Gallery. While he was in town, he and Jonathan Wilkinson invited friends and associates to an extraordinary,

even unprecedented display. It took place in a disused printing works in Rotherhithe, a vast labyrinth of a building with endless corridors – a bit reminiscent of the Alain Resnais film *Last Year at Marienbad*, but with a post-industrial vibe.

As it turned out, it was the place that used to print the *Evening Standard.* Now all the presses had gone, leaving a hall perhaps ten metres high and twenty-five long, with irregular walls, indented with bays and doors. Along the old factory floor there was an array of massive projectors. Over a couple of hours, a long succession of Hockney pictures was shown in vivid colour and on a heroic scale. A picture of the Grand Canyon from the late 1990s was succeeded after a while by a photocollage from 1982 of his then lover Gregory Evans swimming in a pool. This intimate image was transformed into an all-enveloping mural, in which – by some technical abracadabra – the water seemed to be rippling. The still picture had turned into a movie, or at least a GIF. Then one of the panoramic drawings of La Grande Cour was shown, more or less the size of the actual house, wrapped around the inside of this cavernous structure. The effect was quite unlike looking at these works on a gallery wall. When one of his multiscreen films was shown, taken from a car moving very slowly down a country lane in East Yorkshire, you seemed to be passing underneath each roadside tree.

DH [excitedly] You are looking up at the branches! And the colour is absolutely *there* on the wall. This is something new in pictures. Why did the painting of spectacle go away? After all, people love spectacles! It went away because of the cinema, but the cinema isn't that good at presenting spectacle. The only cinemas left now in America are in the malls, where they show all these car-crash movies for teenagers.

At the end, the head of the technical team asked him if he would like to draw directly on the walls. After a moment's thought, he decided to have a go, and sat at a large screen on which he drew with a stylus. He tried a few experimental doodles, then, line by line and stroke by stroke, he put a series of palm trees on three sides of us. The experience was like being in a theatre as a set was assembled out of thin air all around. Or, another way of thinking about it, it was drawing as live performance art. But though we did not realize it then, performances of any kind were soon about to cease.

*

Following his plan, in early March Hockney went back to France and began to draw on his iPad. However, in accordance with *its* own built-in programme, Covid-19 was rapidly spreading across most of the world.

4 March 2020
Dear Martin
I think I will be in Normandy for the next year. I have started drawing on the iPad again as Jonathan has got a man in Leeds to make a new version of the Brushes app, which I think is very good, even better than the previous one, which is now unobtainable.
Come to Normandy again soon.
Much love
David H

That last proposal, it soon became apparent, was not to be possible for a long time. Within days, first France and then Britain were locked down as the full scale of the unfolding pandemic became clear. But in the little world of La Grande Cour,

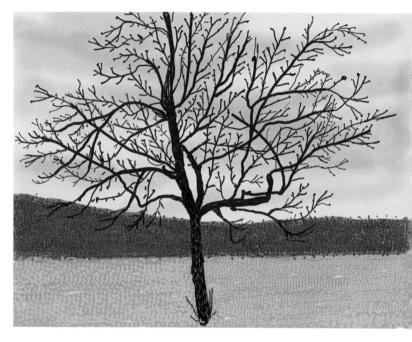

No. 99, 10 March 2020

the alteration was less drastic. It did not affect the unfolding
process of spring at all.

15 March 2020
Dear Martin
How are you in Cambridge? Is it still reasonable?
We are very isolated here anyway, and I don't have
to leave the property to find a lot of interesting trees.
I am at the moment drawing the winter trees, although
as you can see, some of them have small buds already.
I am trying to do as many as I can and then I will
do them again and again as they change. Don't worry
about us, but they are closing most of the shops and
cafés and cinemas. At the moment we can manage.
Much love
David H

So instead of meeting face to face, after a while we settled into
a routine of talking via a FaceTime video call, often at 6.30pm
French time: the cocktail hour. Sometimes, while we spoke, I
would have a glass of wine in Cambridge as he drank a beer in
Normandy.

6

Locked down in paradise

In the last book that we wrote together, *A History of Pictures*, Hockney observed: 'Now you can live in a virtual world if you want to, and perhaps that's where most people are going to finish up – in a world of pictures.' More rapidly than I had suspected, that was where a large number of us had indeed ended up – at least, partly. For the rest of the time, we were living in an old-style, local life circumscribed by the distance we could walk. In my case, the boundaries had shrunk to an area comprising the centre of Cambridge and its surrounding fringes of countryside; in Hockney's, it was his house, studio, garden, and meadow with the little stream at the bottom.

Many office workers, now relocated to spare rooms, attics, and garden sheds, soon began to complain about their new, virtual working life with its interminable round of meetings on Zoom or Teams. They claimed that, for some reason, these were more tiring than conventional non-virtual conferences, perhaps because it is necessary to concentrate harder as there are fewer clues to the other peoples' reactions than in real life. Conversely, as Hockney pointed out, you get more information than you would in an old-fashioned, voice-only telephone conversation.

DH Seeing the other person's picture while you are talking
 to them alters the experience. You can have a pause in
 a conversation if you can see the other person's changing
 expressions, whereas if there's a pause on the phone,
 you don't know what's wrong. So you speak in a different
 way, don't you, if you see the face?

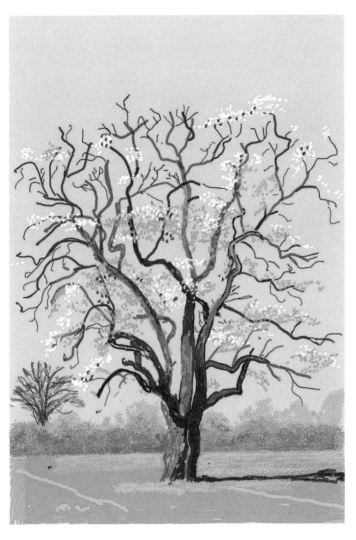

No. 136, 24 March 2020

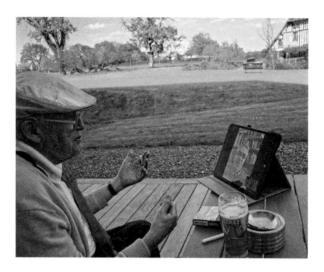

The artist talking to the author via FaceTime, 10 April 2020

For someone such as Hockney, who suffers from deafness, this is a definite advantage. Not that our FaceTime calls always went smoothly. The problem was not in understanding what's being said, but varying signal strength in rural France. Some days and times seemed better than others. Certain conversations started well then encountered technical difficulties. Sometimes he would suddenly freeze, effectively turning him into a still. Presumably I froze too, because he would start saying, 'Hello?, Hello?, Hello?' Then the transmission would get better again for a minute or two, or not. The effect can be almost stylistic, art historically speaking. When colour television arrived, apparently Hockney noticed that by turning up the knobs, the picture could be made Fauvist. With FaceTime, you can get accidental effects much like late Bonnard.

DH At the moment, the picture of you is just a fuzz. The rays of the sun are coming through your window, and they are blurring the picture. Actually, it looks rather good.

MG I've got a good view of your shadow too. I'll try another day.

DH I'm always here.

On other occasions, the signal was better and conversation flowed on and on. On 29 March, we had our usual evening call.

DH I'm sympathetic to anyone who's locked down on the twentieth floor. In a New York high-rise, it wouldn't be so good. But if you are in the right place, the lockdown has its pleasures. Here, it's just ravishing. I'm looking out of the window right now and I can see a ripple of light on the bark of the trees, which looks absolutely beautiful. It's caused by the sun on the trunks as it slowly goes down. It's gradually moving, so you have to get it quickly.

It's the most beautiful spring here. It's early. Last year, it was a bit later. It's spectacular. And I'm getting it down. I'm so turned on. It's not finished yet. The apple trees haven't blossomed. There's nothing on them, but they're about to come out. On some other trees, the blossom's coming out right now; it's all just amazing. I've just drawn the cherry blossom on a great big tree. It's the only one we've got, but it looks glorious right now. Next the leaves will come. I'm going to go on until you start to get the deep green of the summer. That will be a little while yet. In East Yorkshire, it's later, because it's a bit further north, even if Normandy has a similar climate. One year, the hawthorn in Yorkshire came out a week or more later than in London. And in another year, 2006 or 2007, it hadn't

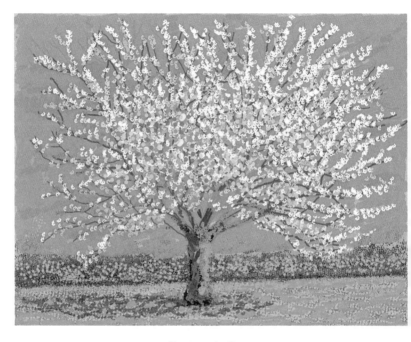

No. 180, 11 April 2020

even come out by early June. In East Yorkshire, we watched seven springs altogether, from beginning to end, carefully – always looking to see what was coming out: what was first, what was second. People just don't notice the spring sometimes.

MG I suppose your experience of living in your farmhouse – not moving far away, not seeing many other people, unpolluted by street lights at night, no traffic noise even during the day – is quite similar to what it would have been like for someone living there when it was built in the sixteenth or seventeenth century.

DH Yes, it is – although not completely. This house is really like the one where the seven dwarves live in the Disney film, isn't it? There are no straight lines; even the *corners* don't have straight lines. We haven't done anything to alter it. There are still only two bathrooms. I have one and the other is downstairs. But we have showers and things. Isn't that what Kipling wrote in his poem 'A Truthful Song', about an ancient Egyptian meeting a modern builder: 'Your glazing is new and your plumbing's strange, / But otherwise I perceive no change'. That's true, isn't it? Although he was Kipling's contemporary, I doubt van Gogh would have had much plumbing in the Yellow House at Arles.

MG We are all suffering deprivations. Physical meetings with real flesh-and-blood friends are difficult; long journeys are almost impossible. I must admit that I'm beginning to suffer from travel-withdrawal, a longing to go to India, Italy, France, Greece, Mexico, Japan, other parts of Britain. But even Wales is closed to travellers.

DH Well, in the past I was deeply attracted by Romantic notions, to Romantic music, to seeing *new* things. I was eighteen when I first came to London. I went on the train. The first thing I did was to run out of King's Cross Station just to see all the red buses – anything – because it didn't look like Bradford. I liked that. I also remember going from Bradford to Manchester when I was very young. We went on a bus over the moors, and as you descended into Manchester, the streets looked the same. But I noticed that the doorknobs were in the middle of the door, not at the side, which is what I was used to seeing. I thought that's really interesting: in Manchester, they are in the middle; in London they might be at the top; and in New York, there might not be any doorknobs at all – everything would be electric. I liked the differences. It's partly visual. Everywhere I went, I wanted to rush out and *see* it; that's a Romantic thing. It's a pleasure through the eye.

But for me *now*, this is a perfect place to be. J-P was just in Paris and he said you could taste the air again there, because there were fewer cars. The air is wonderfully fresh here. I can't hear that much, but in Los Angeles there's always a permanent rumble. In New York, it's worse. I don't want to go there again if I can help it; it's not a place for me at my age. Actually, I could never work there – there would be constant visitors.

*

Meanwhile, out in the wider world, Hockney made a striking impact just by continuing what he was doing in his own garden. On 1 April, he released some of the iPad paintings that he had done to the BBC. Immediately, they appeared on the front pages of several newspapers, including *The Times* and the *Guardian*.

No. 132, 21 March 2020

It's hard to think of another example of freshly made landscape and still-life pictures so rapidly becoming not merely a 'respite from the news', as the headline on the BBC website proclaimed, but a major story in themselves. It was a remarkable demonstration of the power of pictures, the attraction that they still hold for a large number of people, and their capacity to convey thoughts and feelings. Hockney added a few reflections to accompany the drawings:

> 'I intend to carry on with my work, which I now see as very important. We have lost touch with nature, rather foolishly as we are a part of it, not outside it. This will in time be over and then what? What have we learned? I am almost 83 years old, I will die. The cause of death is birth. The only real things in life are food and love, in that order, just like our little dog Ruby, I really believe this and the source of art is love. I love life.'

This was perhaps the closest to a manifesto that he has ever come. The message, though positive, is a tough one: 'The cause of death is birth.' But the pictures transmit that idea through visual enjoyment or, to use an old-fashioned term, beauty.

DH I think that there's a pleasure principle in art. Without it, art wouldn't be there. You can almost drain it away, but it still has to be there. It's like in the theatre. Entertainment is a *minimum* requirement, not a maximum. Everything should be entertaining. You might go to higher levels, but you always need to accomplish that at least. The pleasure principle in art can't be denied; but that doesn't mean that all art is easy and joyful. One can get a deep pleasure from looking at a picture of the Crucifixion. At the Alte Pinakothek in Munich, there are two pictures

Lucas Cranach, *Cardinal Albrecht of Brandenburg Kneeling before Christ on the Cross*, 1520–5

of the Crucifixion by Lucas Cranach. One of them is very, very powerful. It has Christ on the cross, with blood running down his body, in terrible pain. Next to him is a very pious clergyman in a red coat, with fur that you feel would be gently touching him. You wonder how two human beings could be in such utterly different states. One is in comfort, and you can see it; the other is in agony, and it's terrible. Yet I get great pleasure from the picture. So would anyone else. There's pleasure in pain. When we speak about pleasure in art, we are not just talking about looking at flowers.

On the other hand, there isn't any enjoyment in the personal *experience* of pain (except for masochists, of course); and there is nothing but distress at the sight or sound of other people's pain (except for sadists). The pleasure that Hockney is talking about here is the one that comes from viewing the world and everything in it, including suffering, warfare, and death, in a *picture*. This is a process of contemplation carried out not through words but visually. It is enjoying the world, and understanding it, by looking. A picture is an interpretation of the world, so it is also a means of communication, directly via your eyes into your mind.

DH My French is very primitive, but when somebody asked me if it wasn't a bit difficult living here in France not being able to communicate, I answered, 'How do you mean? I've had three exhibitions here!'

In 2019, the year before the pandemic struck, I published a book about travelling to look at works of art. One such journey involved a round trip of about six thousand miles to contemplate minimalist sculptures in the Texan desert. The point was not the distance travelled, but the importance of standing physically in front of the works themselves. Seeing the actual thing, I argued, was fundamentally different from looking at it in a book or on a screen. In the case of a work by van Gogh, for example, you are standing in the same place relative to the canvas in which he once stood, feeling the energy of his hands as he made the painting. Amidst the pandemic, unless you live within walking distance of a notable sculpture, looking at art in a book or on a screen is all there is. When lockdown began, my email inbox was flooded with messages announcing that art institutions all over the world were closing until further notice. A few days later, there was another deluge of announcements

of online exhibitions. This raised two questions: Is there really a substitute for seeing the real thing? And, indeed, are there ways in which a virtual experience is actually better?

It's definitely less trouble. You can stroll around the masterpieces of the Rijksmuseum, the Louvre, or the National Gallery of Art in Washington while sitting at home in front of your laptop. Naturally, it is not crowded as it would be in reality. In other respects, the process is almost the same. You can select a painting, and move in to examine it close up, read the accompanying information, and then (virtually) step back. It is still just a photograph though – better than nothing, but more a reminder of the genuine artefact than a substitute. It is characteristic of the online world that it simultaneously expands and contracts experience. You can go anywhere and see anything at the click of a mouse, but only transformed into illuminated pixels on a computer screen.

DH Whereas my iPad pictures are made on this thing we're talking on, so they are more real, aren't they? I'll send you this one I was just making; in a moment, you'll see it. The vanity of artists is that they want their work to be seen. I have that vanity, I admit. More than anything else, that's what you want. It's very amusing to read the stories of how artists tried to attract attention at the Royal Academy in the eighteenth and nineteenth centuries; how Turner tried to upstage Constable, for example.

The moments of friction between those two painters were often about whose pictures were placed in the most advantageous position at the annual RA exhibition. Turner once thought that Constable – responsible for hanging the show that year – had deliberately sidelined one of his own pictures. An eyewitness described him attacking his rival for the offence 'like a ferret'.

The author at home, with Leon Kossoff's
etching *Fidelma*, 1996, on the wall behind

One year, on Varnishing Day, when painters would add finishing touches to their works before the exhibition opened to the public, a large ambitious picture by Constable was placed next to a small, grey seascape by Turner. While Constable was away, Turner added the red disc of a buoy to his own picture, thus distracting the eye from the other's canvas. On his return, Constable noted wryly, 'Turner has fired a gun.'

MG What do you think when you see something very good by another artist?

DH Well, you think, 'Hmmm, yes!' You're impressed. You get a bit jealous perhaps. I feel that, even of the etching on the wall behind you – by Leon Kossoff, isn't it? It's very, very good. It looks strong. He was always good, I thought. I liked him a lot.

MG Even when museums and galleries eventually reopen,
 I expect visitors will have to wear masks and stand
 metres apart.

DH Well, that's OK – preferable, in fact. I don't see shows
 that are absolutely packed now, but I used to hate doing it.
 When I saw the Picasso show at the Tate Gallery in 1960,
 you had to queue outside. But I'd go down there early,
 so I'd be among the first in. Then I'd go straight to the
 end of the exhibition, and walk through it backwards
 because that way you had it to yourself. I went to see the
 Matisse Picasso show at the Tate Modern in 2002 with just
 Lucian Freud and Frank Auerbach. You could compare
 paintings, look across the room, go back to them. There
 was also an Andy Warhol exhibition at Tate Modern
 at the same time. I remember thinking you could send
 somebody else to see that and ask them to tell you about it,
 but the Picasso you had to go and see for yourself.

Just now, unless you happen to own one, seeing a Picasso in
the original is an experience that has to be postponed into an
indefinite future. Travel at the moment has to be on a micro-
scale: exploring the small area that is within reach, more and
more closely. And, it turns out, just about everything is there.
The opening line of William Blake's poem *Auguries of Innocence*,
'To see a World in a Grain of Sand', is not asking the reader to
do anything fanciful. On the contrary, though the poet may not
have entirely realized it, this is no more than the sober truth,
scientifically speaking. Similarly, Walter Sickert once pro-
claimed that, 'The artist is he who can take a piece of flint and
wring out of it drops of attar of roses.' In other words, a painter
can find enjoyment and poetry in the most unpromising chunk
of stone.

It is true. All the subjects for the profoundest of art are to be found in a small stone or a flower bed. Recently, I've been reading a book called *The Planet in a Pebble*, by Jan Zalasiewicz, which takes as its starting point a rounded piece of Welsh slate. The author goes on to find in the stone's constituent materials the entire geological development of the Earth, over billions of years, and before that the origins of the Solar System, and so all the way back to the Big Bang.

Such a history makes the description 'ordinary' seem an unsuitable one to apply to that Welsh pebble. But everything we can see is equally extraordinary. Thus, Blake's second line, suggesting that we can see 'a Heaven in a Wild Flower', is far from eccentric. It's just what Hockney is implying when he calls the landscape of Normandy or East Yorkshire 'paradise'. But then, of course, he adds that most people wouldn't notice the Garden of Eden if they were walking through it. They'd spend their time scanning the ground to make sure they didn't trip over tree roots. The world is very, very beautiful, but you've got to look hard and closely to notice that beauty.

That is something in which art and artists specialize. Art tends often to be about objects that are normally thought to be unimportant and ordinary, such as trees, flowers, rocks, pools, clouds, crockery, furniture, and glassware. These are, of course, the subjects of landscape and still-life pictures, including many of the most celebrated paintings in the world. Artists find interest in everyday details that almost anyone else would ignore.

DH Each time I do a still life, I get very excited and
 realize that there are a thousand things here I can see!
 Which of them shall I choose? The more I look and
 think about it, the more I see. These simple little things
 are unbelievably rich. A lot of people have forgotten that.
 But you can remind them.

No. 717, 13 March 2011

No. 316, 30 April 2020

7

A house for an artist and a painter's garden

DH In the Bible and other ancient texts, every important place
is a garden. Where would you rather live? Where would
you want to be? Even in Los Angeles, I am always drawing
my garden. Actually, LA is a very green city. People think
it's all freeways and concrete, but that's not quite right.
Wild animals live around my house near Mulholland
Drive. It's not an ugly place. But the air here is absolutely
fresh. They don't talk so much about air these days. They
used to. Ilkley in Yorkshire was advertised for its bracing
air. Bradford didn't have that; it was all smoky. People
would go to Ilkley, only fourteen miles to the north, for
their holidays during the war. Even though I was used
to the smoke, I could still taste the fumes on Kensington
High Street; and New York was abominable. But I can *feel*
the air here. I sleep with the window wide open. I always
do, summer and winter, because I smoke in the bedroom
and it might fill up with smoke. From every window in the
house, you just look out at trees – that's all there is. We're
surrounded by greenery. It's fantastic, for me.

We're already planning for spring 2021. We're going
to plant some more trees, and take others down to create
vistas, so that you'll get a distant view and then something
else closer. J-P says he's making the garden different from
others because he knows it's all about *drawing*.

J-P must have heard that last remark, because at this point his
face appeared on my screen and explained what he'd been doing.

J-P Country people are not sentimental. They'll chop anything down. We have a little wood, not very big but large enough to give the *feeling* of a wood. When we started converting the studio, the first thing they said was, 'We can cut it all down and put the earth we've dug out there.' That was because they were not interested in *looking* at trees. Landscapists come and say, 'This should come out and that should come out; it's got no value.' They want to replace the trees with better, nobler ones. But I know that for David, visually it's the shapes and forms that count. He can make a bit of gravel with some weeds growing on it interesting. They don't see that.

DH J-P's been working on the garden for a while, and from time to time he asks me what he should do next. Vincent, who brings us the milk and eggs, comes and spends two afternoons working in the garden every week. He cuts the lawn. He's a nice chap, but he complains and says that it looks as if there's no one caring for this garden. But there is. I don't mind that, because I *draw* the weeds.

MG It's different if you are designing a garden as the subject for an artist, in the same way that arranging fruit and vegetables for a still life would be different from cooking.

DH Some garden design experts have even said that Monet's garden was not that special! But for Monet it was. He arranged colours from flowers. He was an authority on horticulture; he had books on it in his house. And he organized the whole thing in terms of colour. J-P says that his garden was like a palette. What's wonderful when you go to Giverny is to think about

Claude Monet, *The Artist's Garden at Giverny*, 1900

the *paintings* of it, not photographs. Photographs of gardens are OK, but paintings of gardens look a lot better, particularly if they are by Monet!

Just as the camera does not see space or sunsets as the human eye and brain perceive them, neither does it register the colours of flowers in the way that we experience them. That is why photographing a spring meadow, for example, is a frustrating business. Where you see a mass of wild blooms – red, yellow, blue, and white – the lens minimizes these hues and records mainly grass and leaves. Monet's painter's-palette flower beds might not appeal to a serious aficionado of the herbaceous border. But then what a painter finds interesting will not delight every eye ('willows, old rotten planks, slimy posts, and brickwork' were on Constable's list of his favourite things). So arranging a garden for an artist to paint is different from making one for a horticulturalist, a tree-fancier, or a lawn-lover. Conversely, what makes for a good painting or drawing is not necessarily the sort of prime specimen that would please a landscape architect or arboriculturalist.

DH The three big pear trees are all dead at the top; that's why there are no leaves on them. But I want to let them stay there like that, because they look like hands clapping or something. It's the same with those trees with the mistletoe, which kills them eventually. But I think they are wonderful to draw, because they set up a *plane*. Even in the winter they do. Where the little Christmas tree is, near the end of the drive, there were five trees around it that were chopped down. But a bush has grown up from the tree trunks in only a month, already one or one and half metres high, so you can't see the Christmas tree any more.

No. 318, 10 May 2020

In the garden at La Grande Cour, the dying pears and the mistletoe-infested branches are reprieved, but other elements of the landscape have been nipped out – edited, you might say – because they obstructed the artist's gaze. A painter's garden is devised to produce interesting pictures, not prize dahlia or perfect trees.

DH We just took another bush down because it spoilt the view, and we're thinking of taking down that square bush because it stops you from seeing the tree behind it. But I didn't put in the one that blocked my view when I made a drawing of the scene. It's not about *measuring* the landscape. You can't measure pleasure, can you?

The relationship between an artist's house and that artist's work is sometimes symbiotic: the environment suggests paintings, but those surroundings can in turn be adjusted so they are more suited to being painted. It is, in effect, a positive feedback loop. At Giverny, the flowers in the beds were arranged and selected according to Monet's taste: lighter colours, dense textures, as far as possible a continuous display of colour. When eating in his dining room, he sat facing the window and looked straight down the main axis of the garden, so he could simultaneously contemplate the ever-changing effects of light on the flowers and leaves. The routine of the household and his guests was geared to the artist's daily timetable, and that in turn depended on the light of the sun. Like Hockney, Monet watched closely for the first shoots of spring.

DH Monet was a *great* painter, and the life he lived I think was perfect for an artist. His house wasn't that grand. In those days, people were building fake chateaux – there are still lots of them around. But he just bought a farmhouse with a walled garden, and that was what he wanted: the walled garden – a big one. He accepted the building as it was, although he did it up and made it comfortable. The kitchen is good. He had bacon and eggs for breakfast, because he'd had it at the Savoy Hotel in London and liked it. It was cooked by somebody else; he had a cook there.

The entertainment *chez* Monet was simple. There was lunch, followed by a stroll around the gardens and a visit to the studio: eating, talking to the artist, looking at his subjects, then at the paintings. That was the unvarying itinerary.

DH When he had visitors, he only ever had lunches. They would start the meal at 11.30am, because he would have

been up painting at six, every day in the summer, like
I was in East Yorkshire. People would come on trains,
and he would send a car – he bought one, with a chauffeur
– to pick them up at the Vernon station. But if they hadn't
arrived by 11.30am, he would start lunch anyway, then
went back to painting. He never had guests for dinner,
because he'd be in bed at nine o'clock so he could be up
at five or even four in the morning.

An artist's house quite often merges into that artist's work.
This happened not only in Monet's case, but also – to take just
a few other examples – in Matisse's, Bonnard's, van Gogh's,
and, it seems very likely, Vermeer's as well. It is not hard to
understand why. These were the immediate surroundings:
subjects that were always in view and perpetually available.
Furthermore, to an extent these spaces could be controlled
and arranged like a studio. Indeed, the house often was the
studio and vice versa.

Hockney's house and studio on Montcalm Avenue in the
Hollywood Hills has been the subject of many pictures, includ-
ing a series of the sitting room and wooden terrace in strong
Hockney blue, painted over the years. From the beginning of
his stay in Normandy, the whole complex – inside, outside,
studio, grounds – has been his main, almost his exclusive,
subject. But there is a difference. The LA house was so exten-
sively remodelled that it could almost be claimed as a work of
art in its own right: a unique specimen of Hockney architecture-
cum-interior design. Parts of it indeed seem to be merging into
pictures – or perhaps more accurately stage sets. The bricks
around the pool are real, but have been painted a deeper red,
with the mortar around them more crisply touched in. The
cupola above the large living and dining area is constructed
in a quasi-Cubist manner, as a roof light might have appeared

Large Interior, Los Angeles, 1988, 1988

in a work by Picasso or Juan Gris, but in three dimensions. Then after it was built, Hockney translated this interior into a space-exploring, neo-Cubist painting.

For a while in the late 1980s, he lived more or less permanently in a little house and studio on the coast at Malibu. This was the first time he went into an artistic version of what in a religious context is called 'retreat'. His life there prefigured his present existence in Normandy, but instead of being surrounded by the soft hills and trees of inland countryside, he was confronted by the might and majesty of the Pacific Ocean. At the time, Hockney described the experience like this:

'At one side of my little house at Malibu is the Pacific Coast Highway, at the other is the beach. I step out of my kitchen door and there, right there, is the sea. So when I am painting in my studio I am very aware of nature, in its infinity, and of the sea endlessly moving....

I painted the little house itself, its interior, its exterior, the sea, and what was behind, which was all the landscape. All these pictures were painted together from late 1988 to 1990.'

In most of those paintings and prints – at this time his favoured medium for the latter was the fax, then cutting-edge technology – the dominant presence is the Pacific. Even in the cosiest of the interiors it encroaches, a blue expanse stretching to the horizon visible through large windows. In several pictures, the secure comfort of the interior and the heavy waves are piquantly counterposed; thus a genteel tea setting that might have been seen on a table in Bradford or Bridlington is juxtaposed with the tumultuous, swelling ocean.

Breakfast at Malibu, Sunday, 1989, 1989

It's not fanciful to imagine there was a Far Eastern aspect to that little house on the shore. Hockney seems to have regarded it as an observation station for looking at the sea and sky, much as the Japanese built special viewing platforms to watch the moon. And somewhat in the same spirit as the moon-watching parties of Japan, he shared his exhilarating experiences of light and space with his guests – generously, but also compulsorily.

DH In Malibu, from December to about February, I could see the sunrise and the sunset from my living room. Because Malibu faces south, and the sun rose over Santa Monica and set on the opposite side over the sea, you could see the whole day. Once I was in the bedroom with a little balcony upstairs, and there were these clouds. The sun coming up amongst them was fantastic! So I got Henry Geldzahler, who was staying with me, out of bed. He mumbled and grumbled, 'Oh, you're a bully!' But then he came outside – and he was silent. He realized it was stunning, and you just *had* to get up to see it. Most of the time, you're asleep and miss seeing the sunrise!

*

A house for an artist does not have to be elaborate; usually it is better if it is not. Rubens is a rare example of a painter who lived in a grand mansion – two, in fact, one in Antwerp and one in the country – but even in his case there was a practical reason: he was running a huge workshop, almost a small painting factory, which required a lot of space. And his houses and their environs suited his grand pictures, and often found their way into them too. His greatest landscape, *A View of Het Steen in the Early Morning*, is a view of his rural estate and the surrounding countryside just after sunrise.

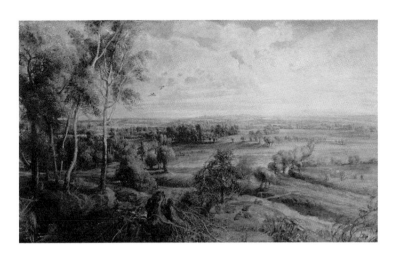

Peter Paul Rubens, *A View of Het Steen in the Early Morning*,
probably 1636 (detail)

The richly opulent landscape around Het Steen was right
for Rubens, but the Yellow House in Arles suited van Gogh in
every way, not only his budget, but his art as well. He liked
things that were rough and simple, as he wrote to his brother.
'What a mistake Parisians make in not having a taste for crude
things!' You can see them in his paintings: the simple vase of
'common earthenware' in which he arranged the sunflowers for
the most celebrated flower paintings in the world; the straw-
bottomed chair just like the ones in the nearby restaurant.

Van Gogh's friend, Second Lieutenant Paul-Eugène Milliet,
could not understand why anyone would enjoy painting 'an
ordinary grocer's shop, and such stiff, square houses with no
charm at all'. It is true that the Yellow House was not a conven-
tional subject, but it was a perfect one for Vincent. His life was
there, as he explained in a letter to his brother Theo: 'The house
to the left is pink, with green shutters; the one that's shaded by
a tree, that's the restaurant where I go to eat supper every day.
My friend the postman lives at the bottom of the street on the

Vincent van Gogh, *The Yellow House (The Street)*, 1888

left, between the two railway bridges.' It was a challenging scene to paint, 'the house and its surroundings under a sulphur sun, under a pure cobalt sky', but he wanted to conquer it for that very reason. 'Because it's tremendous, these yellow houses in the sunlight and then the incomparable freshness of the blue.'

Like Monet at Giverny (and Hockney at La Grande Cour), van Gogh recognized in the Yellow House the perfect dwelling and working place for him – and perhaps for nobody else – as he walked past the little building every day in his early months in Arles, on the way to paint in the fields. He did not change it much after renting it in May 1888, just had the outside painted a creamy yellow like 'fresh butter', with green woodwork, and had gas installed in the studio so he could work after dark. He was intrigued to read in a Parisian newspaper, *Le Figaro*, about a modernist house built allegedly in the Impressionist manner. It was constructed, van Gogh wrote, 'as would be the bottoms of bottles, of bricks of rounded glass – purple glass. With the sun glancing off it, the yellow glints flashing from it.'

DH [laughing] Purple glass!

Van Gogh's own ideas were much more truly modernist, in their simplicity and unpretentiousness, as well as much cheaper. Soon after he moved into the Yellow House in September 1888, an idea struck him: he could make this place his own by filling it with his own works. 'Without changing anything at the house, either now or later,' he told Theo, 'I'd nevertheless like to make it, through the decoration, an artist's house.' Within a few weeks, he listed fifteen pictures that he included in this 'decoration'. Among them were the painting of the house itself and a series of the municipal gardens opposite his front door. The Yellow House did not have a garden, but he regarded this public space on its doorstep as effectively part of his dwelling.

Vincent liked the effect of concentration created by cramming a lot of large pictures into a small space (the narrow, wedge-shaped guest room intended for his friend Paul Gauguin was only three metres across at its widest). He imagined that, in doing this, he was making an interior in the Far Eastern manner that he so admired. He wrote in a letter to his sister Willemien shortly after moving in: 'You know that the Japanese instinctively look for contrasts, and eat sweetened peppers, salty sweets, and fried ices and frozen fried dishes. So, too, following the same system you should probably only put very small paintings in a large room, but in a very small room you'll put a lot of big ones.' Adopting this principle, he wanted 'to stuff at least six very large canvases into this tiny little room'. So the guest room contained two sunflower pictures – the one now in the National Gallery in London and the one in the Neue Pinakothek in Munich – plus four of the park. Thus 'opening the window in the morning, you see the greenery in the gardens and the rising sun and the entrance of the town'; and looking around the walls you would see Vincent's pictures of the same subjects.

'To find the real character of things here,' van Gogh thought, 'you have to look at them and paint them for a very long time.' This was an advantage of staying in the same place: 'I'll see the seasons come and go on the same subjects.' Like Hockney, he was one of a line of painters, including Rubens and Constable, whose subject was a small area of landscape they knew well.

DH That's a big advantage! It obviously was for Monet at Giverny; van Gogh would also have known in Arles what times of the day he should be in various places. You have to know an area very well to do that. It was the same for the photographer Ansel Adams. He lived in Yosemite, so again he would have known exactly when to be at a certain place when the light and the shadows would be perfect.

Vincent van Gogh, *Jardin Public à Arles*, 1888

Just as Hockney has come to know and love his trees – the pears, the cherry, and the ones with mistletoe in their branches – as old friends, so van Gogh became hugely interested in a certain bush that fascinated him, 'nothing special – a round cedar or cypress bush – planted in grass'. He did one painting of it, which has vanished, leaving only drawings to suggest what it might have been like. One fabulous little sketch, crackling and fizzing with energy, was included with a letter that he sent to Theo: a late-nineteenth-century postal equivalent to the visual updates on his work in progress that Hockney sends out, sometimes several times a day, by email.

DH Van Gogh's life in Arles must have been quite pleasant, even though nobody liked him there, because he went out painting every day. Painting away would have made him

happy, then he'd come home and eat the beans he'd left on the stove and write to his brother. Writing the letters was just like talking to Theo. In later years, he would have been on the phone to him instead, and the letters wouldn't have been left for posterity.

MG I'm sure that he was saying the same things to Gauguin. One or two phrases he wrote to Theo are echoed almost word for word later on by Gauguin.

DH Sometimes if I write three emails to three different people, I realize I've written the same sentence to each of them.

No doubt van Gogh intended his arrangement of Gauguin's bedroom as a friendly gesture: 'Welcome to my world, Paul!' The effect must have been amazing, an exhibition conceived for just one viewer, total immersion in Vincent, and quite a shock for Gauguin – an older, better-known painter who thought of himself as the leader – when he first stepped inside.

DH The Yellow House must have been stunning, decorated with van Gogh's pictures hung everywhere, with the two *Sunflowers* in Gauguin's bedroom! He must have thought, 'This work is better than mine! It's very, very good!'

MG The photographs of your house filled with pictures of your house reminds me of his project to decorate the Yellow House with pictures of the house itself.

DH Well, that's what I'm doing. I've done the fire and the fireplace, the windows, the flowerpots. I'm doing everything. In this room where I am now, we've got five big pictures. Wait a minute and I'll show you.

Inside the house at La Grande Cour, July 2020

No. 227, 22 April 2020

8

The sky, the sky!

DH We had a stunning sunset last Thursday. I could see
it was going to be good because there were lots of high
clouds and also open sky. The setting sun was beginning
to light them. So we sat there for an hour, Jonathan,
myself, and Jonathan's partner Simone – J-P wasn't here.
Then when the sun had gone down and we were just
seeing the black pear tree against the light, we turned
around. Next you have the twilight, which lasts here for
about fifty minutes. In LA, it lasts three or four minutes
before it's gone. I pointed out how rich the greens were
at twilight, and how if you really looked, the trees were
purple. I've noticed that and shown it in the drawings.

It was a marvellous evening we had, just sitting
there. The changing sky was fantastic! It was the most
fabulous, luxurious light show really. It went from being
dark grey and white, then orange and red, and all the time
the greys were changing. It was absolutely spectacular.
Nothing could be a greater spectacle than that. I said
we were living in great luxury, being able to see this.
Probably not many other people really *saw* it – I don't
know. Photographs of sunsets are always clichés. That's
because they show just one moment. They don't have
the movement, and so they don't have space. But painted
ones will get that. When you think of it, the sun is the
furthest prominent thing that we can see: it's a good
few million miles away. So we are seeing all this distance.
Photographs can't capture that.

This is a characteristic thought of Hockney's; apparently simple and straightforward, yet unlikely to occur to anyone else. You can only comfortably and safely look at the sun when it is rising or setting, perhaps veiled in cloud or mist so that it resembles a red Chinese lantern low on the horizon. When you do so, you are in fact gazing at an object approximately ninety million miles away. A dawn or sunset is thus a sort of cosmic stage set, in which you are looking along a vista arranged from quite near to very far. In the picture opposite, the trees are perhaps a few metres away; the low hill, some hundreds of metres distant; the clouds up to twenty miles, depending on their height; and the star performer, the sun, much farther than any human being has ever travelled. I found considering it in this way, spatially, changed the experience.

DH I look out at the sky every morning, because each day it will be different. If there are some clouds in a clear sky, the dawn will be *spectacular* because it will catch the clouds first before it comes up. For a glorious sunrise you need clouds, don't you? I saw that in Bridlington, where I could watch the sun rising over Flamborough Head from April to about August, then it moves south. Right now in the summer, I draw the sunrise from our kitchen window, and it's just straight ahead, but in December it's moved down further south. Yesterday, there was a moment when it spread out all over the sky. It doesn't last long. I get up every morning to see them, but this morning it was just a mist. It was a Bradford sunrise, I thought – you couldn't see it at all.

The sunrise at Bridlington in June is too early for most people; it happens at about quarter to five in the morning. I remember I would take people out to see it, and then we would go back to bed. I once took Marco Livingstone and

No. 229, 23 April 2020

Celia out when the sun had just risen. Because there are no mountains or anything, all the shadows are very low as you go west. It was fantastic looking at it! With these low shadows and all the shadows in the trees, and the sun on the outer leaves. It made it *very* clear. It was splendid. But you have to be up at five o'clock to see it. I had to get them up. Celia was complaining, saying 'I can't come!' I said, 'Just put on your slippers and get in the car.' She did – and she thanked me afterwards.

*

Hockney has recently made animated versions of his drawings of objects such as trees seen in changing conditions, including sunrises, sunsets, pouring rain, or the shifting seasons. They remind me of Andy Warhol's celebrated film *Empire* from 1964. This consists of eight hours and five minutes of footage of the Empire State Building at night. It begins with the setting sun – a white screen, because the exposure was arranged for night filming. Then the famous building slowly appears. The shot never alters. Nothing much happens: lights go on and off in buildings; and occasionally the faces of Warhol and the crew appear, reflected in the window through which the footage was shot. But essentially it is a study in inaction. Perhaps it is no accident that it lasts the same period – eight hours – that is conventionally considered a good night's sleep. *Empire* is a poetic *reductio ad absurdum*: a comment, both witty and pro-found, on film and our expectations of constant change. It reveals how much in life does not alter at all, at least at the speed on which movies function. But Hockney's animated land-scapes are the reverse: they emphasize the degree to which many sights that we normally think of as static – dawn, rain, trees, the setting sun – are actually constantly in motion. Our

Andy Warhol, film still from *Empire*, 1964

error is to think of them as stills at all, which we do perhaps because we memorize them as landscape pictures. But in reality, few landscapes are motionless, even in the short periods for which we normally look at them. A tree is an unusual subject for a movie, but if one thinks about it, obviously they move all the time. In the interval between typing this sentence and the one before, I glanced out of the window and saw the trees outside shifting in the breeze, the leaves rustling, the branches waving. Over the previous days, weeks, month, and years, there have been innumerable variations in them – growth, decay, spouting, and withering – all of which are visible over time.

DH That's why you have got to draw them. I'll send you an
animation of quite an old oak tree on the top of the hill.
Some time ago, at the beginning of spring, I drew it
from the house, but I didn't send it out because I thought
it was a bit flimsy. Then I drew it with pale green leaves,

and I didn't send that one out either. Next I did the darker leaves. Finally, I did the clouds, but instead of sending that out, we did it as an animation. Jonathan and I are doing a few of these animated drawings. The first one was just some clouds rolling by, but when we did the rain, I thought that was much more interesting. Then I thought we could do an animation of a sunrise, now I know how to draw it. We did that yesterday and this morning.

His short movie of dawn is in itself spectacular. It begins with a darkened landscape, the view from his kitchen window of a little hill, the flat ground of the garden and a couple of bare trees. The sky is already much lighter, translucent, partly clear but with layers of cloud, which are tinged with pink, orange, and purple. Then a slither of brilliant gold appears over the horizon: the rising sun. Quickly, spiky lines appear like the petals of a flower, radiating from a central disc that is now white. As the greens and shadowy blues of the ground emerge from the dark, the bottoms of the little clouds turn golden, the radiant beams of light cover the whole landscape until the screen turns a solid, brilliant yellow. This is something new to art history: a Hockney monochrome. He has drawn pure light. Then the punchline pops up, written in his signature jaunty-style letters, each casting a small shadow: 'Remember you cannot look at the sun or death for very long.'

DH I think we can call it that, can't we? It's profoundly true, actually, isn't it? Long before they put their 'Death awaits you' warnings on cigarette packets, there were all these buildings that reminded us that death was coming. They were called churches. Religion is seriously declining, which is perhaps why there are so many people now who are obsessed with death.

Stills from *'Remember you cannot look at the sun or death for very long'*, 2020

The pay-off line at the end of the animation reminds me of the arresting title that Damien Hirst gave to his celebrated work consisting of a dead shark preserved in a tank of formaldehyde: *The Physical Impossibility of Death in the Mind of Someone Living*. By that, I have always presumed that he meant the impossibility of *imagining* or conceiving death. It is true. My heart attack gave me a hint of what dying, or at least one variety of it, might be like: a sensation of the vital systems being closed down or switching off, the visual field growing dim, the limbs reluctant to obey instructions to move. But those are all, of course, experiences that come, or might come, at the end of life. Being dead, to have no sensations at all, that's something utterly dissimilar, precisely unimaginable.

The message at the end of the short sunrise film hints at the underlying theme of all the drawings that Hockney has done. The cycle of the seasons is a progression from new life through maturity to decay. That is obviously what happens to us, as well as to leaves and blossoms. His outlook, however, is the opposite of despairing. As he put it so succinctly when he released his group of iPad paintings to the BBC at the height of the coronavirus outbreak in the spring of 2020, 'I love life.'

In our conversations, he also implied that his continuing zest for living was fuelled by making art. 'Perhaps artists can live to a ripe old age because they don't think about their bodies too much; they think about something else. I've still got a lot of energy, even though I'm nearly eighty-three.' Perhaps he would agree with Turner, whose last words were, allegedly, 'The Sun is God.' One can't help wondering whether he might have actually said, 'The Sun is *good*', meaning this is a fine day, particularly for a painter.

DH If it were projected, the yellow of the sun in the animation would dazzle you. It dazzles a little bit on the iPad.

MG I must admit that I'm addicted to light. When the sun is shining, I automatically feel that it's a good hopeful day. An overcast sky makes me feel a little low.

DH I am too, that's why California was always good for me. When the filmmaker Ernst Lubitsch was in Berlin in 1933, he said to a German lady who was a gossip columnist, 'Why don't you leave and come to California where the sun shines 320 days a year?'

In the past, Hockney has often explained that one of the attractions of the American West for him was the strong light. As a child in Bradford, looking at Laurel and Hardy films, he had noticed the strong shadows on the ground and deduced that the sunlight there – unlike that in industrial Yorkshire – must be powerful. In his 1976 memoir *David Hockney by David Hockney*, he suggested that it was the sexual freedoms, the beach boys and the body-builders, that attracted him to Los Angeles. But later, he reflected that, perhaps it was really the spaciousness of the place that was the real allure. Perhaps all three were important, and intense colour as well.

 Hockney is not only a space explorer, artistically speaking, he is also a space addict. He craves more of it, admitting to mild claustrophobia. One of his instinctive objections to fixed-point perspective, the Renaissance kind, is that it pins you down. If the vanishing point is fixed, you are too. Your eyes, your gaze, can't move freely. Consequently, it follows that he is allergic to New York, a geometric city, built on a grid, rising in rectangles and sharp-edged blocks towards the sky. For him, it is a specific kind of bad dream: 'a perspective nightmare'. He needs to be able to move freely, visually, through space. When he moved to a house in the Hollywood Hills around forty years ago, one of the things he most liked about his new surroundings was that

'the roads aren't straight and you don't know which one goes down the hill and which one doesn't'. Hockney became 'fascinated by all these wiggly lanes and they began to enter the paintings'. There lies one reason why he likes his new Norman abode so much. It is, as he often puts it, using the word that J-P likes so much, 'higgledy-piggledy', with 'no straight lines; even the *corners* don't have straight lines', a description of spatial fluidity if ever there was one. So, even though he is confined to a smallish zone, four acres or so, he feels free. On these terms, like Hamlet, he 'could be bounded in a nutshell and count myself a king of infinite space'.

*

This lockdown is affecting my own sense of space, and probably everyone else's. As I write, it has been more than a month since I went anywhere except on foot. Inner space is what we are all obliged to explore at the moment, because we cannot physically travel anywhere.

DH Inner space and outer space are similar, aren't they really? You're never going to get to the edge of the universe in a spaceship. You might as well try going on a *bus*. You can only go there in your head.

Have you seen those photographs taken from the Hubble telescope? It looks like underwater stuff, but at least it looks *colourful*. I was struck by the fact that most of the objects in the universe don't have any colour; but the Earth has wonderfully varied colour, which I think makes us special: blue, pink, and green.

That's true. Most celestial bodies we know of are tinted by their minerals and gases. Thus the moon is monochrome, with just a

faint bluish tinge in a landscape of greys and blacks. Mars famously has a reddish hue, from its desert terrain. Only Earth of all the planets that we know is multicoloured, activated by a dynamic process. According to James Lovelock's Gaia hypothesis, the living systems of our planet interact with the inorganic ones in a constant and positive feedback so that the whole functions as a single organism. At the very least, undeniably, this promotes life and is in turn responsive to living organisms. A considerable amount of the Earth's surface (and also of Hockney's recent drawings) is taken up by leaves. Through the process of photosynthesis, they use the warmth of the sun to transform carbon dioxide and water into oxygen, and then more leaves, stalks, trunks, seeds, and fruit, which in turn provide food for a multitude of creatures.

In his book *The Moon*, Oliver Morton explains that the sun's heat precipitates constant change on Earth (whereas the inert moon just heats up, and then, when turned away from the sun's rays, cools down):

'Every second, 16 million tonnes of water evaporated by the Sun at the surface rise into the sky. In the cooler heights, that water vapour condenses into clouds in smooth, soft layers, clouds in tall, stormy towers, clouds like hawks and handsaws and whales, into tiny cloud drops and fattened raindrops, hard-hitting hail, high-floating ice and every other lightness and darkness, softness and hardness of the sky.'

This process of evaporation and precipitation is part of a global system that involves the oceans shipping heat 'in bulk', as Morton describes it, from the tropics to the poles. This movement, along with differing temperatures of land and seas, drives the winds, which move the clouds, which unleash the rain.

Thus everything that Hockney is drawing at the moment relates directly to the unique atmosphere and biosphere, unceasingly interacting, of which we are all part. He is depicting the processes of life. That's what landscapes really are.

DH Did you get my drawing of the little road outside
the studio and a dramatic sky? All the skies I've drawn
here have been done from nature. You start drawing,
then you realize that they are changing rapidly. But I just
go on and alter their shapes sometimes. I think I've got
some rather good ones. I mean, you can't *invent* a sky,
I don't think, or if you do it's obvious.

*

There was a series of so-called 'supermoons' in the spring of 2020, of which the biggest and brightest was on 8 April. These are a natural, and relatively frequent, phenomenon caused by the fact that the orbit of the Earth's satellite is not quite regular. It varies from being between about 360,000 and 400,000 kilometres away from us. When it is full and also at its closest, a supermoon occurs, which is up to fourteen per cent larger and thirty per cent brighter than a normal one. Thus far its enlarged size is entirely a matter of physics, but when the moon is rising or setting, another factor comes into play that is to do with us and our psychology. If it is close to something else in our visual field, such as a mountain, roof, or tree, it will seem even bigger than it would in the centre of a clear, dark sky. This is because we have an object with which to compare it, which in turn is a reminder that size is always relative: large or tiny in comparison with something else (and quite often that something is us). Consequently, in the middle of the night, Hockney saw an outsized, shining disc caught in the branches of a familiar tree.

No. 418, 5 July 2020

No. 369, 8 April 2020

DH I just got up for a pee, and saw it through the window. I
drew it quickly on the iPad. If I'd had to use brushes and
paints, it would have taken much longer and I would have
lost the impact it had on me. I thought my drawing was
rather good. It gave a much better idea than a photograph
would have done. I was looking at the moon for quite a
while, and when you do that, you see this halo around it
that you don't see in photographs at all because it's too
far. That's an example of the way lenses push things away.
In a lens view, it would be disappointingly small.

His moon-awareness connects Hockney in Normandy with the
Far East. In Japan, there are autumn festivals called Tsukimi,

held each September and October, that are dedicated to viewing the harvest moon, with parties thrown and guests invited to do so in company. One of Hiroshige's 'One Hundred Famous Views of Edo' represents a *Moon Viewing Point* – a sort of open veranda sticking out into the sea. La Grande Cour, miles from any other habitation except an occasional farmhouse and with minimal light pollution, also makes an excellent natural moon-viewing vantage point.

DH My niece said that she tried to photograph a big moon, and I said, 'Well, no, you have to *draw* it, like the sunrise. It can't be photographed because it is the source of light.' You couldn't photograph the sunrise either, because there'd be a point where it would be too bright for the camera, or you'd have to shoot it through a dark glass. So you have to draw it, like I drew the rain.

MG The moon has been in the news lately because of these super-sized ones, in March, April, and another due in May.

DH They couldn't stop the moon could they? The moon just goes on, it's *inexorable*. 'In the news lately!' [laughs]

At that point, the subject switched abruptly from the night sky, full of stars, to another variety of stardom altogether: the kind created by television, radio, films, and other ways of broadcasting words and pictures.

DH I'm fed up with the news! It's all about coronavirus and President Trump. I think Trump is one of the last of the TV people. He became famous for being the host of a programme on television. His celebrity was created by the media, but that's dying rapidly.

The sky, the sky!

MG Fame is a strange phenomenon. Not everybody who
deserves it gets it. But once you've acquired it for whatever
reason, it's very hard to lose it.

DH J-P was just reminding me that there was an old Wesleyan
Methodist Chapel – I've photographed it – in Stamford
Bridge [near York] that is now a skin-care centre. That
change of use seems to sum it up. The building had gone
from worrying about the soul to worrying about the
surface only. When we were doing the production of
Die Frau ohne Schatten [a Richard Strauss opera, which,
by the way, has a highly Hockneyesque title: 'The woman
without a shadow'] in Los Angeles in 1993, we were going
to pay a visit to Schoenberg's house in West LA, but what
really made people want to go along was that it was three
doors down from O.J.'s house, where the murders had
taken place. Schoenberg lived on the same street.

MG That combination, O.J. Simpson and Arnold Schoenberg,
could be the winning entry in a competition to find the
two people in twentieth-century history with the least in
common. Indeed, the sole connection is that they are both
famous, but for quite different reasons.

DH [laughs] Sometimes I get fed up with being famous myself.
I've always thought it was a mad world, and I've always
said so, but I think it's going a bit madder now. I'm just
going to stay here, where we can keep the madness of the
world at bay.

No. 470, 9 August 2020

No. 584, 31 October 2020

9

Sumptuous blacks and subtler greens

DH I've just sent a get-well card to a friend by email. J-P said
to me that, 'You've no idea how nice the messages you
draw on your iPad are to receive, with all the colourful
letters. You don't think much about it, but they really
mean a lot to people because they don't get other messages
like these.'

MG Well, it's true – they do. We printed out your Christmas
and New Year messages and stuck them on the wall;
they are still there. Josephine was saying the other day
perhaps we should take them down as it's a long time since
Christmas. And I also liked your proclamation about the
virus and economics [overleaf]. You almost put the words
in lights, like something you might see on the front
of a Broadway theatre. It's as if you are making the colours
a part of the message.

In the past, it was believed that there was a language of
colour. Vincent van Gogh wrote that he hoped to discover,
for example, how 'to express the love of two lovers through
a marriage of two complementary colours, their mixture and
their contrasts, the mysterious vibrations of adjacent tones.
To express the thought of a forehead through the radiance of
a light tone on a dark background. To express hope through
some star. The ardour of a living being through the rays of a
setting sun. That's certainly not *trompe-l'oeil* realism, but isn't
it something that really exists?'

No. 135, 24 March 2020

Now, not everyone would agree with or approve the idea of depicting love 'through a marriage of two complementary colours'. When I talked to Robert Rauschenberg one time, he strongly objected to the thought of the Abstract Expressionists, his predecessors, forcing some innocent colour such as red to express their innermost feelings and psychological problems.

DH Hmmm. Rauschenberg wasn't really all that good
 with colour, was he? He wasn't what you would call
 a *colourist*; not at all, I thought, when I went to see
 his exhibition at Tate Modern. To be a colourist, you
 need to *know* and *enjoy* colour, don't you?

Each of those conditions is important, and Hockney himself fulfils both. His enjoyment of colour was revealed by a little anecdote that he told a few days later when we happened to be talking about black.

DH I was once in Japan, getting a prize or something,
and a princess came in – an old lady – and she had on
this black dress, and you could see straight away that
it was made up of three different blacks, and then there
were distinct shades of black within those. It was
wonderful, I thought. I was very impressed. I've always
remembered it.

He had been in Tokyo to receive the first Praemium Imperiale
for Painting, awarded by the Japan Art Association in 1989,
which he won jointly with Willem de Kooning, while Pierre
Boulez got the award for music, and I. M. Pei, the one for archi-
tecture. It was quite an honour for Hockney and a notable
occasion, but characteristically, what had really stuck in his
memory were those three subtle, sumptuous blacks.

Although the fact is sometimes forgotten, black is a colour,
indeed one of the most important, as Henri Matisse himself
noted in a little essay from 1946. 'The use of blacks as a colour
in the same way as the other colours – yellow, blue, or red – is
not a new thing', he wrote. 'The Orientals made use of black as
a colour, notably the Japanese in their prints. Closer to us all, I
recall a painting by Manet in which the velvet jacket of a young
man with a straw hat is painted in a blunt lucid black.' Black,
Matisse concluded with a musical analogy that Hockney would
fully understand and approve, was a crucial element in the
harmony of colours, comparable to 'the double bass as a solo
instrument'. Of course, come to think of it, Hockney himself is
also a master of black, and has created some of his most memo-
rable works, such as the charcoal *Arrival of Spring 2013*, using
nothing else. As our discussion of black continued, it turned out
that he had had another moment of revelation involving that
colour, and an artist whom no one, including, it seems, Hockney
himself, would associate with him or his work.

DH　During the summer of 1991, when I was in New York,
I went to the Museum of Modern Art to sign some prints.
It was on a Wednesday, when the museum was closed.
As I was leaving, the curator who was taking me back out
said, 'Would you like to see the Ad Reinhardt show?'
I must have shrugged my shoulders a bit, but I said,
'Yes, OK.' Then, to my surprise, when I started looking
into them, I found them incredibly beautiful. There was
a room of monochrome black paintings, a room of red
paintings, and one of blue. I stood in front of each painting
and just looked, gave each one three or four minutes'
attention. Then I'd move on. I realized how *subtle* they
were, and I really enjoyed the exhibition. Afterwards, just
down Fifth Avenue, I met Raymond Foy, the art publisher,
and he said, 'Have you seen anything good recently?'
I replied, 'Yes! I've just seen the Ad Reinhardt and it's
marvellous!' He couldn't believe me at first.

Reinhardt was deliberately painting at the threshold of what
we can perceive – what psychologists have dubbed JND, or 'just
noticeable difference' – as a way of forcing us to pay attention.
You have to spend time with one of his pictures, physically in its
presence. There's no other way to experience it. His all-black
paintings seem slowly to develop in front of one's eyes, as
photographic film used to do in the darkroom. The process is
exactly the same as the one that occurs when you are in an
almost lightless space – stepping outside at starless midnight
or into a cellar. At first, you perceive nothing; then bit by bit the
rods and cones of your eyes adjust and a composition appears
– a grid of squares, often arranged as a cross – and instead of an
unvaried black, you notice a delicate range of hues and tones.
The pictures were in fact built up from layers, successive coats
of colour. Each square in the grid is made up of red, blue, or

Installation view of the exhibition *Ad Reinhardt*, Museum of Modern Art,
New York, 1 June to 2 September 1991

green mixed with black to produce an intensely dark, deep
shade. The photographs recording that exhibition look like a
sort of hoax or practical joke: a gallery hung with oblong pic-
tures of unrelieved, solid black. But that was part of Reinhardt's
point: you had to be there to see them.

DH They are *unreproducible*; you can't see them in a book.
Images that are more graphic can exist in reproduction
and you can still get a lot from it. But an Ad Reinhardt
would look hardly anything at all.

Reinhardt's prescription for a painting – 'formless, no top, no
bottom, dark, no contrasting colours, brushwork brushed out
to remove brushwork, matte, flat' – makes him seem like the
opposite of Hockney. But clearly there was a shared interest in
chromatic subtlety, which is part of what Hockney means by
knowing colour.

DH We've just got a new printer. Instead of eight colours, like our last one, it has eleven. It has another green, another violet, and another red. Then it has a matte black for ordinary things and a photo black for printing photographs. Before it arrived, I said, 'Well I should think the greens are going to be more subtle on this. But probably I am going to be the only user to see them, because if you are just using it to print photographs, you will hardly notice the differences at all.' I had done a picture using lots of greens, and we printed it on the old machine and on the new one. You know about RIRO, don't you? Rubbish in, rubbish out. If all you are doing is dealing with colour photography, it's really a question of RIRO, because a lens won't register the subtleties. Humans see colour in a different way, although not everybody notices the differences. When I was first in Yorkshire, I was driving along with a friend and I said, 'What colour is the road?' He said, 'I see what you mean. When you really look at it, it's a *violet* grey or a *pink* grey.' I said, 'Yes, it is, but you have to really *look*.' Most people don't, so they just see grey tarmac in front of them with green stuff at the side, but not that many *different* greens. So I think this printing machine must have been made just for me!

The way he was looking at that stretch of rural road in East Yorkshire was much the same as the way Reinhardt wanted people to look at his black pictures – really hard, so that they could see the smallest distinctions between violet black, say, and reddish black. But there is also a fundamental dissimilarity, of course: Hockney was observing the real world. He seldom discusses colour in the abstract, partly, perhaps, because it is hard to do so. We do not really have the vocabulary required to describe multiple, subtly differentiated shades of green.

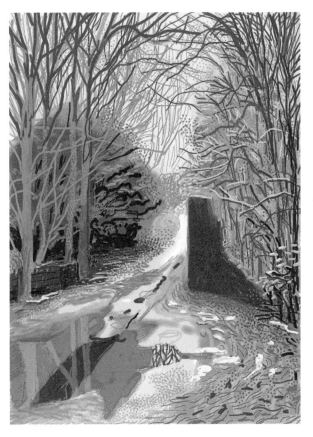

*The Arrival of Spring in Woldgate, East Yorkshire
in 2011 (twenty eleven) – 2 January, 2011*

For that, we would require a different language, perhaps resembling that of the Inuit. The much-repeated claim that they have fifty different words for snow is a simplification, but is not without foundation. In fact, they, and also the Sami people of northern Scandinavia, multiply their descriptions of things through what is called 'linguistic polysynthesis', or sticking words together, to create terms that mean 'fresh snow', 'fine snow', or 'soft, deep snow' – much like Hockney's 'violet grey' and 'pink grey'. Nonetheless, there is a limit to how far you can communicate about colour unless the person you are talking to is also doing what Reinhardt demanded of the viewers of his pictures: looking really hard. Snow is important to Arctic-dwelling peoples, so they view it with concentration. The exact colour of the road isn't that important to most drivers in East Yorkshire, so they don't notice it. But it matters to Hockney.

Another reason why he seldom talks about colour in the abstract is that to him it is always particular: an aspect of the real world. Talking about Cézanne's paintings of card players for our book *A History of Pictures*, he said that it was not easy to articulate what was so powerful about them: 'It isn't just the sense of volume; it isn't just colour. I think they are almost the first truly honest attempts at putting a group of figures in a picture.' He has always been doubtful about art that does not represent the real world, what we call, for want of a better word, 'abstraction'. But that does not mean he doesn't appreciate it, as his reaction to Reinhardt's paintings shows. As long ago as 1977 he told Peter Fuller, 'There *is* a difference between painting that veers towards music, in the sense that it's about itself or a pleasurable sensation of looking at something that doesn't refer to other sensations from a visible world. Take colour field painting: it can be stunningly beautiful. But, for me, that's just one little aspect of art.'

*

Colour is not an entirely objective phenomenon. What we see is not what a photograph reproduces, as Hockney pointed out when talking about his new printer. Old colour photographs of interiors lit by electric light were tinged with yellow because electric light is yellowish. But no one actually sitting in those rooms saw them like that, because their minds adjusted and tuned the yellow tinge out. Similarly, most people do not register the violet tone of a Yorkshire road, because their attention is not focused on it, but he does.

One of the most obvious developments in British painting from the 1940s to the 1960s, if you forget about stylistic labels, is that by and large it gets much more colourful. It is as though at some point, the sun had come out. This is true of many, quite dissimilar artists: Francis Bacon, Peter Lanyon, and Frank Auerbach, for example. In each case, in the early 1950s, their works had been relatively sombre and monochromatic, but a decade later their palettes all brightened. In part, this reflected a real material change. As rationing ended and the country's prosperity increased, clothes and other manufactured items became more cheerful in hue. And this reflected a change in mood. Increasingly, people felt more optimistic, especially the younger generation. The world seemed to be more colourful.

DH Yes, it did, or at least for me it did.

Several of the students who started at the Royal College of Art in the autumn of 1959 were interested in Fauvism. Matisse, Marquet, and the other members of the so-called Fauve group had been dubbed 'wild beasts' because critics were shocked by the strength of their colours. This was not an approach that had much appealed to British artists previously, or indeed even been noticed by them. Allen Jones, one of Hockney's contemporaries, remembers a life class in which the teacher, Ruskin Spear,

brusquely enquired why, since it was a grey London day and the model was equally colourless, he had depicted her in bright red and green. Fauvism was the subject that Hockney chose for the thesis he wrote (under protest, since he thought it was a pointless diversion from making art) for his diploma. Over the next decade and more, however, though his colour was beautiful, clear, and strong, it was more reminiscent of the Quattrocento masters Piero della Francesca and Fra Angelico, whose work he loved, than it was of the Fauves. The direct influence of Fauvism on his work came later, after his stay in Paris from 1973 to 1975, at the same time that he was so struck by free-flowing 'French marks' while he was designing the first of two triple bills for the Metropolitan Opera in New York. In the sets and costumes, he recalled, 'I used the colours of Matisse – red, blue, and green.' In other words, he turned up the colour knob.

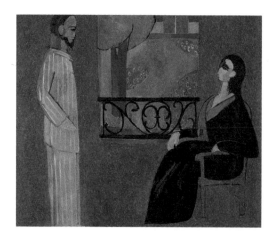

Henri Matisse, *The Conversation*, 1909–12

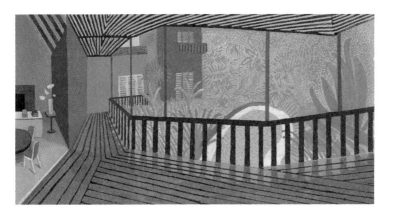

Interior with Blue Terrace and Garden, 2017

He then decorated his Los Angeles house in 'Matisse colours'. 'I painted the terrace of my house blue in 1982, after I'd been in New York doing the sets for *Parade*, a ballet, and two operas. When I bought this house, I used the same colours. The painters thought I was quite mad. But when they finished, they saw how good it was.' Matisse is not an artist that Hockney mentions as often as he does Cézanne, Picasso, or van Gogh. But there is a connection. When the *New York Times* critic Roberta Smith reviewed his eightieth-birthday retrospective exhibition, she highlighted the connection. 'He's followed through on the dense blue, green, black, and red of the French modernist's implacable 1909 masterpiece *The Conversation*, like no one else, Matisse included.' That's quite a tribute, but she's right. It isn't just landscape and portraiture that Hockney has carried on, regardless of the claims of critics such as Clement Greenberg that they had been superseded by the onward march of art history. He's also continued the whole tradition of

Parisian high modernism in the same spirit. As Smith also wrote, he's proved 'that the legacies of Fauvism, Cubism, Post-Impressionism, and biomorphic abstraction are ripe for further development – assisted by healthy doses of scale, magnification, spontaneity, and saturated colour'. Hockney's instinctive contrarianism was no doubt useful in ignoring the voices of those who told him he could not paint what he wanted. Greenberg was the most influential writer on art of the late 1950s and early 1960s, exactly the time Hockney was coming to maturity. But he paid no attention to what Greenberg proclaimed.

DH I knew him a bit. He was an interesting man, but he had some daft ideas. For example, that it's not possible to make a portrait any more; by saying that, he was handing everything to photography! He was the Francis Fukayama of art history, saying the history of painting had reached its end with colour-field abstraction. He thought that Kenneth Noland and Jules Olitski were doing important things. I couldn't see it at all.

Greenberg thought that Cubism led to abstraction, but it didn't for Picasso and Braque. I think the lessons of Cézanne and Cubism should not be forgotten. No critic's going to get everything right. Look at Ruskin. If you read him on Whistler, what he wrote was just terrible. He didn't understand him and it's very uninteresting. One of the critics' complaints about my show of Yorkshire landscapes at the Royal Academy in 2012 was that the colour was gaudy, but I don't think so at all.

In the 1970s, Hockney was keen to break out of what he calls 'the trap of naturalism', a way of seeing the world he associated with photography. As we have seen, we don't experience colour in the same way as a camera; nor, as Hockney often

emphasizes, do we perceive space – or indeed, anything – in the way a photograph represents it. We see psychologically; our eyes, as he likes to say, are connected to our minds. He finally managed to escape from naturalism in 1975. The breakthrough came as a result of reading a poem: *The Man with the Blue Guitar* by Wallace Stevens from 1937. Its first stanza begins:

'The man bent over his guitar,
A shearsman of sorts. The day was green.

They said, "You have a blue guitar,
You do not play things as they are."

The man replied, "Things as they are
Are changed upon the blue guitar."'

He read Stevens' verse while taking a holiday on Fire Island. At first, he remembered, he 'wasn't sure what it was about, it seemed to be about the imagination in some way. But I was thrilled by it. The second time I read it, I read it out loud to a friend, which made it much clearer. It is also about Picasso, about the imagination transforming things, the way you see. I began some drawings inspired by the poem.' These drawings developed into a portfolio of twenty coloured etchings – he had learned the technique in Paris from Aldo Crommelynck. Hockney's etchings do not exactly illustrate the poem, which does not have a narrative in any case. They play with what he took to be its fundamental, and to him 'thrilling', point: that imagination could transform the world and the way we perceive it – and it could do so, according to Stevens' central metaphor, through alterations in colour – or at least in the way that colours are usually experienced. Guitars aren't generally blue, at least they weren't before rock and electrification came along.

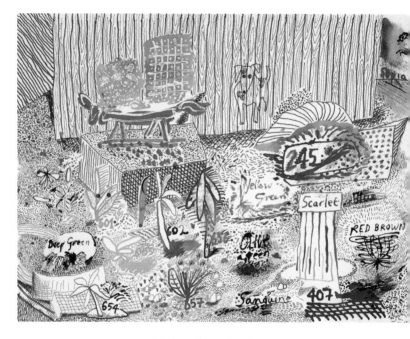

Ink Test, 19th to 21st March, 2019

I Say They Are, from *The Blue Guitar*, 1976–7

Days aren't usually green. But Hockney's etchings play with the idea that you can colour the world any way you desire, whether it's an imaginary realm or a real place. *I Say They Are* features dribbles of red, blue, yellow, green, and black ink apparently standing on a rug in an invented, otherwise monochrome interior. It's as though he is saying: this is a squeeze of pigment from a tube, and I can turn it into absolutely anything I want.

Early in his first year in Normandy, 2019, he returned playfully to a similar theme in some beautiful coloured-ink drawings. They are almost like sample charts, tabulating different pen strokes, types of dot, splodge, and wash, and the various shades available to him in this medium. At the same time, they are whimsical catalogues of the contents of this new rural French world that he is exploring. I suspect these drawings are also a

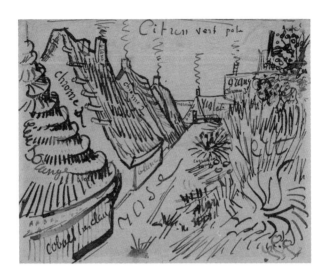

Vincent van Gogh, *Street in Saintes-Maries*,
from a letter to Émile Bernard, Arles, 7 June 1888

nod to the wonderful little sketches that van Gogh inserted into his letters, rather as Hockney attaches his latest works to his emails. Van Gogh's intention was evidently similar. He wanted his friends, though they were far away, to know what he was creating from day to day. But being dependent on the postal service, and using just the ink he was writing with, he would often add notes of the colours that he had used in a particular work in words – '*vert*', '*rose*', '*violet*', '*émeraude*', '*blanc*', and even specific pigments such as cobalt blue – so that his readers could add them in their mind's eye.

When Hockney talks about colour, he often refers to its lasting qualities. Consequently, when he discusses the subject, it tends to be in terms of the pigments he uses, rather than their hue; it is the same when he is actually painting. The former,

being chemicals, have differing properties; some will alter more readily and rapidly than others. He will instruct J-P, standing at the ready, to put some cobalt blue on his palette or perhaps some Naples yellow. He is conscious that the way he makes a picture now will affect the way it will look in a hundred years.

DH Van Gogh had good paper, and good ink and good pens. But sometimes the colour in his paintings is changing now. One of the bedroom pictures was originally a violet colour, which would have been beautiful with the yellow he used. But now it's become blue. A lot of pictures darken with time. Courbet's *Studio* looks as if it must have darkened, for example. I think some of Warhol's have too. He used screen-printing inks, and I think they are going darker. If you don't paint with the right stuff, your pictures won't last. That's all there is to it. There are many pictures painted in Britain in the 1950s that have now gone very dark. In the Royal Academy tearoom, they used to have a lot of paintings from the 1950s and 1960s, by people such as Ruskin Spear, Carel Weight, Robert Buhler – and how dark they were!

MG They were all your teachers from the Royal College. I had assumed that they were dark because the postwar era was rather a gloomy period. It seems that way in retrospect. But maybe that's partly because the pictures look sombre.

DH But my paintings are lasting very well after fifty years; the colours are the same. I've always been conscious of that: if you paint them to last, pictures can last a long time. I think the colour I'm using on these new paintings won't change. It's a slow-drying acrylic, it's like oil, so you can blend it. I use glazes with it that dry overnight.

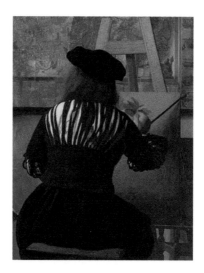

Jan Vermeer, *The Art of Painting, c.* 1666–8 (detail)

MG I was reading about one of Titian's altarpieces in Paul Hills' book *Venetian Colour*. Apparently there are ten layers of glaze between the wood panel and the varnish.

DH There's probably some red or orange in there, I would think. A sumptuous black will often have orange in it. That makes it a bit different, I've found. [And, indeed, one of Titian's layers was brownish red, comprising 'burnt ochre with vermilion and a little lead white'.] Velázquez was very good with blacks too. And the blacks in Vermeer's *The Art of Painting* are fantastic, like Ad Reinhardt. The irregular pattern of stripes on the painter's shirt *animates* his back; it makes you feel that he's doing something.

Jean-Auguste-Dominique Ingres,
Portrait of the Countess of Tournon, 1812

But all colour is a fugitive thing, isn't it, even colour
in real life? It's always changing. Even so, some painters
have always made their pictures to last, even when
they were using colours such as green, which are often
the most changeable. The Ingres portrait that is now in
Philadelphia, of a woman in green, is a terrific painting,
and the green still looks very good to me. So does the
green in Jan van Eyck's *Ghent Altarpiece*. Green was a
fugitive colour for a long time, and in many older pictures
it turned brown. Constable was one of the first painters in
the nineteenth century to use a lot of it. When one of his
landscapes was put in front of the RA hanging committee,
someone exclaimed, 'Take that nasty green thing away!'

And his patron George Beaumont said a picture should be the colour of an old violin. They even used Claude glasses, tinted golden brown, to make the real countryside look more like a picture by Claude. Turner didn't like green much either.

MG I suppose that in the eighteenth century, taste had become attuned to old master paintings that had darkened with time, covered in brown varnish. So Constable's greens looked garish. But, psychologically speaking, green is the colour that dominates our attention. If you show someone patches of red, green, and blue at equal levels of lighting, the green will seem brightest and the blue will be dimmest. It might be because we spent millions of years of evolution scanning leaves, looking for food.

DH Earth colours such as browns and ochres were also the most permanent, weren't they?

MG And so were the very expensive ones, such as lapis lazuli. If you wanted your picture to be painted in lapis lazuli, it cost you more money. That's partly why the Madonna always got a cloak of lapis, if the customer could afford it. It was beautiful, but it was also expensive – so it did her great honour.

DH Rightly so, probably. I bought a tube of that, lapis lazuli, but I thought it wasn't *that* blue.

J-P [in the background] You didn't use it! It wasn't good enough for Hockney blue.

DH No, it wasn't a *Hockney* blue.

Spilt Ink, 2019

No. 263, 28 April 2020

10

Several smaller splashes

One rainy day, a drawing arrived in my inbox of Hockney's little lily-pond.

DH I had to watch the pond for about ten minutes, out there in the rain, then I came in and drew it. I was watching and noting how when a drop hits the water, it makes a little splash, and that causes concentric circles on the surface, which then radiate back again.

Here he had depicted a natural system of impacts and waves, and had done so in ways that were both diagrammatic and sensuously naturalistic. The water looked real enough to dip your hand into, but the rings of ripples were sharply geometric, and the falling rain was represented by black lines: symbols of something transparent and in rapid motion that is hard to see, let alone translate into pictorial form.

DH It's difficult to photograph rain too. When they were filming *Singing in the Rain* in Hollywood, they had to put milk in the water, which mixed white into it, so the camera could see it. Like dawn, sunset, and the moon, it's another thing you have to draw. Hokusai and Hiroshige were very good at doing that. Japanese artists are often excellent at weather. Japan is an island, on the end of a continent, rather like Britain. And it's often very wet; you can see that in their pictures and Kurosawa's films, but there is plenty of wind and sun as well, and quickly changing clouds.

You might say this new picture by Hockney is an *abstraction* of the cascading droplets, much like the torrent of lines scything down from the sky in Hiroshige's *Sudden Shower over Shin-Ohashi Bridge and Atake* of 1857. On the other hand, the soft dark shadow, interrupting the silvery reflection that covers most of his lily-pond, transmits an exact sense of the water: its fluidity, its weight, even its temperature.

Water – whether in ponds, puddles, pools, or the sea – is one of his perennial themes. And Hockney is by no means the only painter for whom that is so. A notable example was Leonardo da Vinci. Fluid dynamics were among his obsessions; again and again, he drew and tried to understand churning streams with eddies whirling like tresses of hair. One of the people to whom Hockney sends out his pictures (which he is doing once or twice a day at the moment) is Martin Kemp, renowned authority on Leonardo, Emeritus Professor of the History of Art at Oxford University, old friend, and ally. After a while, he decided that it would be fun to respond to Hockney's emailed works with another image. The result was a dialogue that must be unprecedented: between an artist and an art historian, about art and conducted almost entirely in visual terms.

DH When I send him the pictures, he sends me back a pictorial comment on them. They're very good; he keeps it up and sends them back pretty quickly. I'm very impressed by his art-historical references. In response to my sunrise, he sent me an illustration from Dante's *Divine Comedy* about how eagles could stare at the sun – apparently this was a medieval belief.

When Hockney posted his raindrop drawing, Kemp swiftly countered with a detail of a painting from 1444: *The Miraculous Draft of Fishes* by Konrad Witz, a southern German artist who

Utagawa Hiroshige, *Sudden Shower over Shin-Ohashi Bridge and Atake*, 1857

Konrad Witz, *The Miraculous Draft of Fishes*, 1444 (detail)

spent most of his career working in what is now Switzerland (of course in those days there was no such state, and no state of Germany either). One of his innovations was setting this biblical episode in a local, Swiss landscape. He moved it from the Sea of Galilee to Lac Léman, with the peaks of Mont Blanc and Le Môle appearing over the nearby hills. In doing so, Witz may have been the first European artist who stared hard at a stretch of real water and carefully depicted what he saw there.

DH Witz had really looked at the water, and he had seen a lot of things: these little circles of bubbles in the shallows, the reflections, the way St Peter's legs look distorted when he is wading towards Christ. I know one or two other paintings by him – they're *very* good.

This *Miraculous Draft of Fishes* was one of the earliest depictions of a subject that fascinated Hockney in the late 1960s: the splash. The ones in Witz's painting are tiny, but Hockney's splashes came in various sizes. *The Splash* of 1966 was famously succeeded by *A Bigger Splash* the following year. He explained not long after he had painted these two pictures why the subject had appealed so much. It was, it turned out, partly to do with time: 'The splash itself is painted with small brushes and little lines; it took me about two weeks to paint the splash. I loved the idea, first of all, of painting like Leonardo, all his studies of water, swirling things.'

What appealed as much was the notion of depicting such a rapid event so slowly. A few years ago, he amplified that account. 'I spent longer on the splash than on any other thing in the painting', he told the American radio station NPR. He didn't *throw* pigment at the canvas to mimic a gush of water, as Francis Bacon did when he painted his *Jet of Water*. 'I wanted to paint it slowly, and I thought, then it *contradicts* the splash, really.'

Photographs from the frontispiece to
Arthur Mason Worthington's *The Splash of a Drop*, 1895

So the paintings of splashes were a sort of game with time in which he treated this moment of liquid turmoil with the care of a botanist describing specimens; in other words, he approached it almost like a scientist ... but not quite.

A photograph of the event, at least a high-speed one, reveals something different from the splash that we normally see and that Hockney depicted. In the late nineteenth century, a physicist named Arthur Mason Worthington pioneered the use of such photographs to study the subject. He analysed the successive cycles of a splash made by a drop of milk falling into a cup of tea, or by a large raindrop into a pool of water. First a crater appeared with jets spouting out from its rim, and then there was a rebound causing a 'column' to emerge. But, he noted, 'there is frequently a curious illusion': 'We often seem to see the crater with the column standing erect in the middle of it. We know now that in reality the crater has vanished before the column appears. But the image of the crater has not time to fade before that of the column is superposed on it.'

This optical illusion – column, jets, and crater all existing simultaneously – is more or less what Hockney painted in his swimming-pool pictures. However, the experience of seeing, even when we pay the closest attention possible, is often like that. What we see is relative to *us*, to our senses, the particular

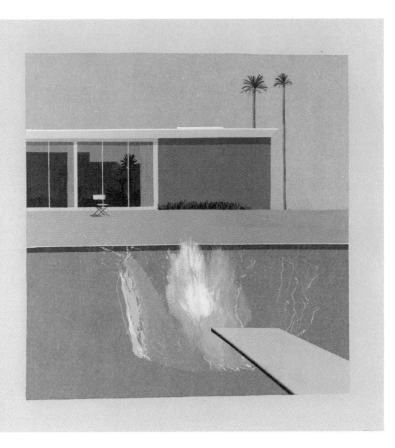

A Bigger Splash, 1967

temporal bandwidth on which we operate: a little slower than the speed of a splash, much faster than the erosion of a mountain. Much of what we imagine to be objective – colour, for example – is really subjective: created by our sensory equipment interpreting the data they receive. That does not make the colours we see less real than the ones registered by a photograph; nor are Hockney's splashes less convincing than Worthington's high-speed photographs. On the contrary, his pictures are *more* like splashes as we actually perceive them. That verisimilitude is what makes these works of Hockney's both witty and profound. They are beautiful, intricate, slowly made representations of something almost instantaneous: thus a joke about time, art, and perception, as well as a careful documentation of the behaviour of water.

Time and scale are relative, especially in pictures. You could make a big image of a small splash, and vice versa. Likewise, the time it takes to depict something bears little relation to how rapidly it is moving or changing. It might take a fortnight to paint something that is over in a flash. Nor does the small size or short duration of an occurrence mean that it is not significant. In his book *How to Read Water*, Tristan Gooley describes how Polynesian sailors can navigate across huge distances in the Pacific by observing the intricate patterns of ripples and waves on the surface of the sea. These give vital clues about the nearness of land or large obstacles such as reefs. They constitute in fact a sort of moving fluid map, in which the vibrations in the water act much as sound waves do in radar, bouncing back from objects in the vicinity.

DH I've just begun *How to Read Water*. It's very interesting. The author says, 'we can learn a lot about what is going on in the world's greatest oceans by looking at a village pond'. So you can read a puddle in the same way as an ocean; the

language of the ripples and splashes is the same. At the moment, I'm painting a big picture of the rain on my little pool. I think I'm going to call it 'Some *Smaller* Splashes'.

*

Hockney is well aware that he is following a tradition. Though water in general (as opposed to the seascape) is not usually defined as a separate theme in art, unlike say portraiture or still life, it is obviously one of the main subjects of many painters, both in the East and the West. Hokusai was the great master of depicting waves, and Hiroshige is unsurpassed at rain (van Gogh took his cue from him). One of Claude's specialities was the dazzling effect of a Mediterranean sun rising or setting on the waves of the sea; Turner, Monet, and Sisley were all fascinated by reflections on rippling rivers and streams.

Monet painted the grand, wall-sized pictures of his Japanese-style lily-pond indoors in a studio. The smaller canvases could

Claude Monet, *Water-Lily Pond*, 1917–19

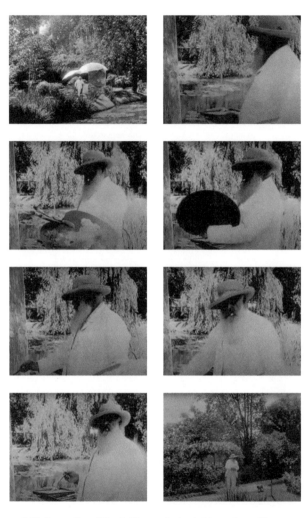

Stills from a film of Claude Monet painting in his garden at Giverny
in 1915, directed by Sacha Guitry for his documentary project
Those of Our Land

be executed outside, or at least partly so. There is a wonderful, though brief, film of him doing just that in 1915. He is positioned beside the ponds, beneath a couple of sunshades to protect him from the glare of the sun, and accompanied by a little dog. But painting, even *en plein air*, is never simply observation; which is why Cézanne was wrong when he reportedly said, 'Monet is only an eye, but my God what an eye!' Making a picture is always a mental operation, and although Monet did not analyse what he saw in the same way as Cézanne himself did, he was organizing and transforming what he was looking at nonetheless. Even when he glanced from pond to canvas, memory would have been involved, and obviously it would have been all the more so when he strode into his studio and depicted something he could no longer see.

DH It struck me that I was watching my pond and making
 mental notes, just like Monet must have done for his
 big paintings of the water lilies, the *Nymphéas*. He must
 have walked down to his pond at Giverny and looked at it,
 probably smoked a couple of cigarettes, then walked back
 to his studio. His visual memory would have stayed fresh
 for an hour or so, probably, of things he'd noted mentally.
 I can't recall a Monet of the lily-pond in the rain, but the
 water garden at Giverny must have been a beautiful thing
 to look at when it was raining.

Jean-Jacques Rousseau felt the same about watching water in movement. His *Les Rêveries du promeneur solitaire* ('Reflections of the solitary walker'), was written in 1776–8, when the Genevan philosopher was nearing the end of his life. It is an unfinished set of ideas that came to his mind as he strolled in the outskirts of Paris. The whole of Walk Five is devoted to a description of the two months of autumn 1765 that he

spent living on a small island, the Île Saint-Pierre, in a Swiss lake, the Bielersee. There, Rousseau was in voluntary lockdown: restricted to a small area eight hundred metres wide and a few kilometres long. Later he described this period as the 'happiest in his life', because he was able to become attuned to what he called, 'the sentiment of existence, stripped of any other emotion'. In other words, he found that on the island he could drift into a meditative state, free of the anxieties and currents of feeling that normally filled his mind. This happened particularly on certain evenings, when he found a secluded spot beside the lake and just stayed there, watching and listening:

> 'There the noise of the waves and the movement of the water, taking hold of my senses and driving all other agitation from my soul, would plunge it into a delicious reverie in which night often stole on me unawares. The ebb and flow of the water, its continuous yet undulating noise, kept lapping against my ears and my eyes, taking the place of all the inward movements which my reverie had calmed within me, and it was enough to make me pleasurably aware of my existence, without troubling myself with thought.'

While he was observing the splashes on his pond, of course, Hockney could not have been in a dreamy trance. He was concentrating hard on what he was seeing and on retaining a clear visual memory of it. But it is likely that the process cleared his mind of the flotsam of worries and stray thoughts that normally fills our consciousness. Several times in conversation with me he has mentioned an example of the 'deep pleasure' that he gets from 'just looking', or from a sight such as 'a little puddle on a road in Yorkshire' with rain falling on it.

Rain, from *The Weather Series*, 1973

DH I have often said that I can enjoy watching the rain in
 puddles, which makes me quite rare. I *like* the rain. I have
 always done pictures of it. I did a print of the rain making
 the ink run, at the Gemini print studio in 1973.

At the time he made that print, he explained, 'I loved the idea of
the rain as it hit the ink, it would make the ink run. The moment
I thought of the idea I couldn't resist it.' It was part of *The
Weather Series*, which also included *Snow*, *Mist*, and *Sun* (Sidney
Felsen, the co-founder of the Gemini studio, joked that he made
them in California, 'because Los Angeles had no weather'.)
Hockney's *Rain* made a visual pun on the watery medium that
he was using – ink – and the fluid nature of his subject. But
more than that, he was making another such rhyme between
the flat sheet of paper on which his image would be printed and
the surface of the water. Here is a clue to the attraction of sheets
of water for painters: they have an important characteristic in
common with pictures. Both have a two-dimensional surface –
but it is possible to see beneath it, behind it, or through it.

DH That's what I look at first when I see any painting: the
 paint itself. And then I might see a figure or something
 else. But first I see the *surface*.

That's exactly what he observed in the pond beside his house:
rhythmic movements radiating in response to the falling rain,
with underneath remaining a still, dark, liquid mass. It is a
contrast, geometric and naturalistic, mundane and profound,
that has intrigued him for more than half a century.

DH That's why I did those swimming pool pictures, really.
 It wasn't the pool itself that interested me; it was the water
 and the transparency. I realized that the dancing lines are

on the surface, they're not underneath it. That's what you are looking at in ponds: surface *and* depths.

*

Water not only transmits movement in the form of ripples and waves, it is also a medium that affects light, refracting and reflecting it. That's why Monet had such a huge subject in his water lilies, one that retained his interest for more than twenty-five years. In his garden ponds, he had water to paint, but also the sky, plants, light and darkness, reflected trees and clouds: in a way, the whole world was there. A pool is a natural mirror – in French such a decorative tank in a park is known as a *'miroir d'eau'*. And so pictures of water are part of a larger category: representations of transparency. Hockney has always described this as a 'nice problem' and a 'graphic challenge'. A transparent object such as a piece of glass is simultaneously there and not there. You can focus on it as a three-dimensional object, or alternatively you can look through it or contemplate the reflections on its surface. It therefore also has some of the same characteristics as a picture. It is at once both a thing itself, and a medium through which you can view other things.

When Hockney sent out a photograph of works in progress including his painting of the pond in the rain, Martin Kemp rapidly shot back with a detail from Piero della Francesca's panel of St Michael in the National Gallery, London. He added a caption, 'in light and in shadow like ripples'. It was an acute comparison, firstly because Piero and Fra Angelico have always been artists close to Hockney's heart, and secondly because it moved on from raindrops on ponds to reflections, transparency, and dancing lines in art more generally. All three are to be seen in the richly embellished skirt worn by the archangel. Each jewel is reflecting highlights like a water droplet, but is also

Piero della Francesca, *St Michael*, 1469 (detail)

transparent so you can see into it. Meanwhile, the decoration on the bronze or leather segments of St Michael's armoured costume swirls and shimmers like undulating wavelets.

The paradox of naturalistic painting is that it is the sparkle and glitter, the ever-fluctuating reflections, that help to create the impression of solid reality. The highlights are in fact lots of tiny mirror images of the world around (in some works by Netherlandish painters such as Jan van Eyck, you can actually see the windows of the workshop reflected in pearls and rubies). Anything transparent automatically contains both surface and depths, just as a painting of any subject does. So Hockney's 'nice problem' – how to draw something that you can see through – is a profound one. It is connected with the larger conundrum of what pictures are, what we see in them, and why we are attracted to them so much.

Hockney likes to quote a seventeenth-century verse on the subject of transparency.

'A man that looks on glass
On it may stay his eye;
Or if he pleaseth, through it pass
And then the heav'n espy.'

DH I've always *loved* that poem by George Herbert. I know
quite a bit of his poetry because I looked it up when I
found that one. It's *very* good because you can look *on*
glass. And if you do look at glass, you can't see through it,
but then your eye can decide to go through it. Especially
if there's dirt on the glass, you can look at that for a while,
and then if you look through the glass you don't see the
dirt. I *love* paintings of glass.

II

Everything flows

MG It looks like a beautiful day in Normandy. The weather's
fabulous here.

DH Yes, it's marvellous. I'm sitting next to the pond. The frogs
are croaking like mad. They're mating at the moment, so
they're croaking all the time.

MG We went for a walk in the Fens earlier and it seemed to be
peak cuckoo-mating time there too. On one path, you could
hear at least half a dozen male cuckoos calling.

DH We have one around here. That's what they have to do;
that's what we all have to do.

MG You mean, it's the natural world's equivalent of internet
dating …

DH [laughs] I've done a picture of the pond à la Monet.
Just now, I was doing the surface of the water. Since
March, I've done at least one drawing a day, often two,
sometimes almost three. That's an average of more
than one a day. I don't even take a nap in the afternoon,
because I get a lot of energy from work, a *lot* of energy.
It's *gorgeous* everywhere I look.
 When you are really painting, you can get out of
yourself, which is, after all, the highest thing most people
feel they can do. I think that's true. Sometimes when I'm

No. 331, 17 May 2020

drawing away on the iPad, it's like that. I don't care
how long it's taking; I don't realize what time it is at all.
I'm often like that.

A Hungarian-born American psychologist named Mihaly
Csikszentmihalyi has formulated a theory of happiness that
describes exactly the kind of experience Hockney is talking
about. Csikszentmihalyi calls it 'flow'. When someone is expe-
riencing this state, he wrote:

> 'Concentration is so intense that there is no attention
> left over to think about anything irrelevant, or to worry
> about problems. Self-consciousness disappears, and the
> sense of time is distorted. An activity that produces such
> experiences is so gratifying that people are prepared to
> do it for its own sake, with little concern for what they
> will get out of it.'

That describes the experience of really, really looking at some-
thing such as a painting. Hockney argues that doing so helps to
relieve anxiety. 'What is stress?' he asks. 'It's worrying about
something in the future. Art is *now*.' And making a painting or
a drawing, though certainly not without difficulties or frustra-
tions, is a process that he finds utterly absorbing and endlessly
self-sustaining. Early in 2020, he gave an interview for the
Louisiana Museum of Modern Art in Denmark. What he said
was typical:

> 'I *have* to paint. I've always wanted to paint; I've always
> wanted to make pictures from when I was tiny. That's
> my job I think, making pictures, and I've gone on doing
> it for over sixty years. I'm still doing it, and I think they
> are still interesting as well. The world is very, very

beautiful if you look at it, but most people don't look very much, with an *intensity*, do they? I do.'

An aside that he made to me one day could serve as an extremely concise five-word biography: 'I've always been a worker.' Jack Hazan, director of *A Bigger Splash*, the fictionalized documentary film about Hockney, observed him in the early 1970s. Hazan found that he was 'completely prolific as a painter; it was all he wanted to do. If you talked to him, after a couple of minutes he'd just drift away back to his studio and start painting again.' He could be describing Hockney right now, nearly half a century later.

In the Book of Genesis, God condemns Adam and Eve to hard labour as a punishment when he expels them from Eden. 'By the sweat of your brow you will eat your food until you return to the ground, since from it you were taken; for dust you are and to dust you will return.' However, it seems that even before that, Adam and Eve were supposed to do the necessary gardening: 'And the Lord God took the man, and put him into the Garden of Eden to dress it and to keep it.'

Even in paradise there is plenty to do. Csikszentmihalyi goes further than that. He implies that work – or at least effort and concentration – might be a large part of what makes paradise delightful. In a similar spirit, the playwright Noël Coward quipped: 'Work is more fun than fun.' Csikszentmihalyi argues that that is absolutely true – at least if you have found an activity that involves you completely, and that presents endless challenges, so you can continue to develop and grow as you apply yourself to it, year after year after year. This is a way of living that fits easily with Eastern ways of thought such as Taoism and Zen. A Japanese sushi chef named Jiro Ono, aged ninety-four on the day I'm writing this, is a striking example. Making sushi, better and ever better sushi, has been his life's

work and sole ambition. He rose from humble beginnings to become the owner of a world-famous restaurant and, decades after most people would have retired, still continues to pursue perfection in the preparation and presentation of raw fish. He dreams about sushi, and said that he would like to die making it.

I once quoted Coward's dictum to Hockney; he countered with another one-liner, a familiar proverb adapted by Alfred Hitchcock, who apparently joked, 'All work *made* Jack.' That witticism no doubt also contains a truth. Not much success is achieved without a lot of effort. But there is a catch. Csikszentmihalyi quotes a psychiatrist, an Austrian named Viktor Frankl: 'Don't aim at success – the more you aim at it and make it a target, the more you are going to miss it. For success, like happiness, cannot be pursued; it must *ensue*.' That is to say, if you do something that you are fitted for, that you love and are good at, success may (or may not) follow. But if you do that, you have succeeded in the most important respects anyway. Clearly, when Hockney as a teenager in Bradford spent all day drawing, then all evening too, he could not have expected wealth and fame to be the result. In early 1950s Britain, very few artists were even able to make a living from their work alone. He tells several stories about his surprise when he first discovered that people were willing to pay money for his pictures. He defined his own notion of a life lived without regrets to Kirsty Lang, who interviewed him for *The Times* in the spring of 2020: 'I can honestly say that, for the last 60 years, every day I've done what I want to do. Not many people can say that. I've been a professional artist. I didn't even teach much, just painted and drew every single day.'

Of course, that would not sound like an ideal existence to many other human beings; few could stand all those endless hours in the studio, let alone enjoy them. But it's the perfect routine for him.

DH It's true painting every day wouldn't suit everybody, but it suits me. If you do that, you live in the now. Painters can live a long time. They either die young or make it to ripe old ages like Picasso, Matisse, Chagall, or my old friend Gillian Ayres. Do you know why? Because when you are painting, you're so involved you can get out of yourself. Well, if you can do that, that's added time. I am eighty-two and I feel fine. Maybe I walk slower.

I read in the newspapers that longevity experts were saying something or other. Longevity *experts*? Can you even be an expert on longevity at forty-five? Or do you need to be at least eighty? I would think so. Anyway, I think longevity is a by-product of a harmonious life. What makes for a harmonious life differs from person to person, but I think there must be some harmony in it if you live to be older: you find your own rhythm.

MG Painting is an occupation at which you can improve with age, which is not true of every human activity.

DH Yes. For mathematicians, twenty-five is a big moment. That was the age that Werner Heisenberg came up with his uncertainty principle. He just used to walk in the mountains and think; Einstein took the tram and thought of relativity.

MG Most physical and many mental skills come more easily to the young. But that's not necessarily true of the arts. There's a story about the Catalan cellist Pablo Casals. When he was eighty years old, someone asked him why he still practised so much. Casals was a bit surprised. He answered: 'Because I want to get better!' Some painters carry on and on, perhaps in the same spirit. Titian was

No. 181, 10 April 2020

somewhere in his late eighties when he died;
Giovanni Bellini was probably around eighty-five;
Monet was eighty-six. All of them were working
almost until the last moment.

DH Well, I think I might! [laughs] Picasso was. Late Picasso
is fantastic! You notice *more* with each successive year;
I am doing that *now*. I can go in and look at things more
closely, such as blossom. I took a branch and brought it
in here to draw as a still life. It didn't last long. I had to
draw it in about four or five hours. It just rots when you
bring it inside and lay it on a sheet of paper. It's temporary,
but most things are.

Katsushika Hokusai had pre-eminently what is known in
Japanese as '*ikigai*'. This translates as 'a reason for being', a
vocation, a '*raison d'être*', as the French say. Hokusai's recorded
remarks bring Jiro Ono the sushi chef to mind, but his own
obsession throughout his long life was making pictures. In
1834, at the age of seventy-four, he wrote a biographical note to
accompany his illustrated book *One Hundred Views of Mount
Fuji*. From the age of six, he recalled, he had had 'a penchant for
copying the forms of things'. As Hockney says, Hokusai was
evidently 'a little prodigy, like Picasso'. However, nothing that
he had done until the age of seventy, Hokusai wrote modestly,
was 'worthy of notice'. At the age of seventy-three, he felt, he
was 'somewhat able to fathom the growth of plants and trees
and the structure of birds, animals, insects and fish'. He was
definitely improving with age:

'When I reach eighty years, I hope to have made
increasing progress, and at ninety to see further
into the underlying principles of things, so that at

one hundred years I will have achieved a divine state in
my art and at one hundred and ten, every dot and stroke
will be as though alive.'

There was an element of self-parody in this, and also in the
sequence of pseudonyms Hokusai adopted. In 1801, when he
was a mere forty-one, he began signing himself 'Gakyojin' or
'Man crazy about drawing', which he then altered to 'Gakyo
rojin' or 'Picture-mad old man'. By 1834, his favourite signature
was 'Brush of Manji, old man crazy to paint'. Most of the works
for which Hokusai is best known were created after he had
turned seventy, and many were signed in that way.

Like Hockney, Hokusai was fascinated by water, and he
was renowned for representing it. One of his most famous
works is a depiction of a wave, *The Great Wave off Kanagawa*.
But quite as memorable as Hokusai's pictures of the sea is his
series *A Tour of Waterfalls in Various Provinces*. These were done
around 1832, when the artist was in his early seventies. In them,
the moving water often seems almost living – like tree roots,
blood vessels, or nerves. They are remarkable depictions of a
subject that changes by the instant, and yet always remains the
same thing: a famous waterfall, such as the Kirifuri in the moun-
tains near Nikkō.

DH *Everything* is in flow. That is one reason why a
drawing is so interesting, as opposed to a photograph.
I like that remark of Cézanne's, 'You have got to keep
painting because it is constantly altering.' Well, it is
actually, because *we* are. It's permanent flux.

Hockney is not echoing Csikszentmihalyi there, but instead the
ancient Greek thinker Heraclitus of Ephesus, who flourished
around 500 BC. One of his insights was summed up in the phrase

Katsushika Hokusai, *Kirifuri Waterfall at Kurokami Mountain in Shimotsuke, c.* 1832

πάντα ῥεῖ (*panta rhei*) or 'everything flows'. The same idea has occurred to people from other cultures at various times. It is the essence of the doctrine of impermanence in Buddhist and Hindu teaching, for instance. The Japanese notion of universal transience is termed *mujō*. This is a theme of the thirteenth-century Japanese classic *An Account of My Hut* or *The Ten Foot Square Hut* by Kamo no Chōmei, which I read recently because it struck me as a good text for lockdown. It's a short book about living in a small, circumscribed zone, not moving around much, surrounded by the natural world. The way of life that Chōmei describes is a bit like that lived by Hockney, J-P, and Jonathan at La Grande Cour, although considerably less luxurious. At the age of sixty, Chōmei relates, he decided to build himself a small hut in the woods, only ten foot square, in which to spend the rest of his life. There he lives far from the frenetic big cities, working when he feels energetic, resting when he feels tired.

In what he does, and loves to do, Hockney is much more like Hokusai. Chōmei just meditated; Hockney is always busy making pictures. But, of course, pictures encapsulate thoughts, feelings, and attitudes, including meditative ones. They can also register time, as Hockney has often said, from the fraction of a second needed to take a photograph to the days, months, or even years an ambitious oil painting or cycle of frescoes might require. Another of Hokusai's alternative names was 'Iitsu', which he took at the age of sixty. This means 'one again', implying that he was starting again on a new cycle – so a toddler once more – but also that he was 'at one' with creation. 'Manji', which he adopted in his seventies, means 'ten thousand things', that is, 'everything'. As we have seen, everything, and absolutely anything, can make a picture – which is itself a remarkable and revealing thought. Chōmei's book begins with a sentence similar to Heraclitus's observation that you cannot step into the same river twice:

'On flows the river ceaselessly, nor does its water
ever stay the same. The bubbles that float upon its
pools now disappear, now form anew, but never endure
long. And so it is with people in this world, and with
their dwellings.'

DH But everything is moving in a van Gogh painting too,
isn't it? You just need to keep still and look at it. I think
my pictures have time in them. They're always flowing,
always, just as nature's always flowing.

While he was at work, Monet complained that 'everything
changes, even stone'. Of course, he was right. In a very slow
time-lapse film, shot over a few million years, even the Alps
would wax and wane like the changing moon or the blossom
on a cherry tree. But Monet probably was not thinking of the
imperceptibly slow processes of erosion but of the instability of
shifting appearances in a northerly, maritime location such as
Normandy. Standing in front of a row of his canvases of Rouen
Cathedral at differing times of day is like looking at a movie of
fluctuating light and atmosphere from dawn to dusk – but far
more subtle than any photographic image could ever be. What
Monet was actually painting was evanescence, passing time.
To observe that, it was not necessary to scrutinize this monu-
ment of Gothic architecture. A row of poplars, that staple tree
of the French landscape, would do just as well, or haystacks,
the theme of Monet's first ever series, which must have been
everywhere in the fields around Giverny. Years later, he gave
one of his visitors, the Duc de Trevise, a deceptively casual
account of how the multiple-picture idea had come about:

'I believed that two canvases would suffice, one for grey
weather and one for sun! At that time, I was painting

Claude Monet, *Haystacks*, 1891

some haystacks that had excited me and that made
a magnificent group, just two steps from here. One
day, I saw that my lighting had changed. I said to my
stepdaughter: "Go to the house, if you don't mind,
and bring me another canvas." She brought it to me, but
a short time afterwards it was again different: "Another!"
"Still another!" And I worked on each one only when I
had my effect, that's all.'

In reality, it was much more of a battle to paint the hay-
stacks, as his words at the time revealed: 'I am working terribly
hard, struggling with a series of different effects (haystacks),
but the sun sets so fast that I cannot follow it.' In trying to
capture the flux of time, even as it affected something as rela-
tively solid and mundane as a lump of carved stone or a haystack,
Monet was trying to do just what Heraclitus had argued was
impossible: he was attempting to step into the same moment
more than once. But each instant was different, and none ever
returned, exactly. Consequently, he felt that he spent his entire
existence 'striving to render' his impressions 'in the face of the
most fugitive effects'. It was frustrating. Monet was never com-
pletely satisfied, and at times despondent. In 1912, at the height
of his fame and more than seventy years old, he wrote to his
dealer, lamenting, 'I know beforehand that you'll say my pic-
tures are perfect. I know that when they are shown they will be
much admired, but I don't care because I know they are bad.'
As Hockney once said to me, 'painting has its agonies'.

DH　When you are working outside, you realize that it's
changing all the time – *all* the time. Then you see how
quickly the clouds move. That's why Cézanne preferred
overcast days – he said that – because the sunshine
wouldn't fluctuate so much. When he was painting, Monet

would have done all the tonalities out in the landscape
– he'd have had to. But on the iPad, I can catch the light
very quickly. I think it's the fastest medium I've ever found,
much faster than watercolour. There is a van Gogh
painting of some trees and one time this lady said to me,
'Well, he got the shadows wrong.' I pointed out that no,
he hadn't; he would have taken an hour or two to paint
the picture, and during that time the shadows would have
moved. So the ones she thought were wrong were actually
right – but at the end of that period. She was thinking it
was like a photograph, when it's all the same instant of
time. A drawing or painting may have hours, days, weeks
even years in it. With a painting, I might take two or three
days, but with the iPad, I've got to finish it more or less
in one go (although sometimes I might work on them a bit
more the day after). I drew one of a little flower bed just
out here about four days ago. I often make deadlines for
myself. Because I'm drawing on an iPad, I think, 'I'd better
do it in a day.'

No. 186, 11 April 2020

No. 580, 28 October 2020

12

Rippling lines and musical spaces

DH I've done only two drawings of the river so far. But I like the moving water, how it just goes like that [he gestures with his hand]. The little ripples and eddies are so good.

MG It's a Leonardo da Vinci subject.

DH Well, it's a subject of *mine* now. I'm going to do a few more. We have some chairs and a table down there, in a couple of places. When we were sitting beside the river the other day, J-P asked me if I could hear the water, but I couldn't. Then we moved along to another place where there's a little weir, and I could hear it – and I drew it.

For Hockney, music and other sounds are intimately connected with the visual world around us. He has long pointed out that his own loss of hearing was related to a growing spatial sensitivity: 'As I got deafer, I could see space more clearly.' This led him to speculate that with other artists there might also have been a similar interrelation of the senses. In the case of his hero Picasso, however, he has mused on whether the link was the inverse.

DH The one art that Picasso had no interest in was music. I've wondered whether he was tone deaf. Maybe he didn't hear any tones, but he could certainly *see* them because he had a better grasp of chiaroscuro – light and shadow – than anybody else, it seems to me.

'Painted floor with garden and French marks',
from *L'Enfant et les sortilèges*, 1979

Hockney's own disability was diagnosed in 1979, since when he has worn hearing aids. And this moment in his career coincided with a renewed exploration of space, while simultaneously he launched himself into freer, more gestural painting and drawing, and his colour became bolder and stronger. All these developments were catalysed in 1980 by two powerful experiences he had in New York: seeing the monumental Picasso retrospective at the Museum of Modern Art, and designing his first French triple bill for the Metropolitan Opera. It was for one of the three short pieces on that programme, Maurice Ravel's *L'Enfant et les sortilèges*, that he made some brush drawings on paper – 'letting my arm flow free', he described it – that he entitled 'French marks'. When he drew these, he knew that the final curtain and sets would be seen by an audience listening to Ravel's score, every aspect of which, including tempo and rhythm, he was acutely conscious of:

DH It's a *gorgeous* piece of music, only forty-five minutes long. When James Levine conducted the revival, he made it last fifty-five minutes! That made it too slow, I thought. In a Wagner opera, it might not matter if it's ten or even twenty minutes longer; you wouldn't really notice if the whole thing is four and a half hours long. But in an opera lasting only three-quarters of an hour, if you add ten minutes, it's quite a large addition.

As he often says, every line has a certain speed, and you can see that when you look at it. The latest drawings of the little stream at the bottom of the meadow at La Grande Cour are also full of French marks, graphic handwriting in the manner of Matisse, Picasso, and Dufy. Each of the loose rippling squiggles has its own direction and momentum. And the gushing, gurgling sound is there too, not audible but clearly evoked.

No. 540, 9 October 2020

That same sound is, of course, also the subject of the second movement of Beethoven's Sixth Symphony – the 'Pastoral' – which the composer entitled '*Szene am Bach*' or the 'Scene by the brook'. In the score, two of the cellos take the role of the softly burbling water, while the rest of the cellos and the double basses play pizzicato. Later, a flute impersonates a nightingale, and the woodwinds, a cuckoo and a quail. This is a landscape painting in sound: the aural counterpart of Hockney's drawing, which is a melodically flowing pastoral picture.

When driving around East Yorkshire in the early twenty-first century, he sometimes listened to Beethoven on the sound system in his car, which has eighteen speakers. It was, he felt, just about the last place where he could hear music properly. He remembers driving along Woldgate to the sound of Glenn Gould performing Liszt's piano version of the Fifth Symphony. Beethoven remains a hero, part of Hockney's deep attraction to 'Romantic notions, to Romantic music, to seeing *new* things'. He was struck by, and vividly described, Max Klinger's over-the-top Art Nouveau monument in Leipzig in which the composer is naked like a classical god and accompanied by cherubim in the manner of a Christian saint.

In 2020, Hockney drew an iPad portrait of the great musician for the 250th anniversary of his birth (a year that turned out, with sad irony, to be one in which live performances were impossible throughout almost the entire globe). The picture immerses Beethoven in French marks, this time closer to those of the pointillists Georges Seurat and Paul Signac: a chromatic atmosphere of swirling and pulsating dots of violet and green.

Hockney's discovery of music more or less coincided with his training as a draughtsman and painter. He spent his late teens at Bradford School of Art – drawing, drawing, drawing all day and most evenings – and some of his few free moments were devoted to listening to musical performances that, even

in provincial northern England, were evidently in those days of a high quality and surprising variety.

DH I went to orchestral concerts from about the age of fifteen. First, I went from school; then at art school we used to go and sell tickets and sit behind the orchestra. I knew John Barbirolli and George Weldon because I watched them conduct. I received a good musical education in those five years from fifteen to twenty. I heard all the great music of the nineteenth century. Barbirolli used to do Mahler, which wasn't that popular back then. The Hallé Orchestra from Manchester also played in Bradford. I used to go to their concerts on Friday and Saturday nights. Every Christmas, there were about eight performances of Handel's *Messiah* by the Bradford Old Choral Society, the Bradford New Choral Society, and some other choral society. And then there was the Huddersfield Choral Society, which was a very big one. I also went to concerts in Leeds because you could sit behind the orchestra for sixpence. Once they had the Vienna Philharmonic. They said they'd never played for such a cheap audience. And there was also the Yorkshire Symphony Orchestra in Leeds Town Hall, conducted by Norman Del Mar until it was disbanded in 1955. So there was a lot of music.

Just as much of an idol for him as Beethoven, perhaps even more so, is Richard Wagner. Hockney spent a lengthy period living within the soundscape of *Tristan und Isolde* while working on a production of that opera in the late 1980s. This was a highly complex project that involved correlating music and drama with space, colour, and light, finding visual and spatial equivalents to harmonies and orchestral textures. One might say that it was an exercise in intersensory translation.

postcard of Richard Wagner with glass of water

Postcard of Richard Wagner with Glass of Water, 1973

DH I made spaces that were very complicated, with four or five vanishing points. Everything Wagner asked for was there. He called for a forest and there it was. My urge to work in three dimensions was satisfied by working in the theatre and using space. That was my way of sculpting.

Hockney likes to quote a line from the libretto of *Parsifal*, 'Time and space are one', pointing out that it was written decades before Einstein conceived his theory of relativity. He loves all Wagner. Designing a production of the entire 'Ring' cycle is an unfulfilled ambition. But perhaps *Tristan*, the most deliriously, intoxicatingly romantic of all operas, is his favourite.

DH I'll go along and see any production of *Tristan und Isolde*, although lots of those that I have seen were just terrible. I've just being reading Alex Ross's book *Wagnerism*. It's really good. He had an influence on painting, on poetry, on everything. [Ross describes Wagner as 'a godfather of modern art, his name invoked variously by Baudelaire, Mallarmé, Paul Verlaine, Paul Cézanne, Paul Gauguin, and Vincent van Gogh'.]

MG In fact, you're a bit of a Wagnerist yourself.

DH Well, he mentions me in the book and my Wagner drives that I used to go on in the Santa Monica Mountains.

After Hockney bought his beach house at Malibu in 1988, he had the idea of orchestrating drives through the mountains from the Hollywood Hills, coordinating the vistas of scenery with music by Wagner played on the car's loudspeakers. Disappointingly, I was never a passenger on one of those musical rides. By the time I was visiting him in Los Angeles,

he seldom left the house, garden, and studio. David Sheff, a fortunate interviewer for *Rolling Stone*, described the experience in 1990. He was taken out in Hockney's then car, a red Mercedes convertible with twelve loudspeakers. He described how as the music spiralled upwards so did the Mercedes, and the lights in a tunnel were synchronized with 'staccato blasts' of Wagner. As the music reached a crescendo, the car breasted the peak of the mountain, and then, as it rounded a corner, right on cue, a spectacular finale in Fauvist colour: 'The Sun appeared – a fiery orb, searing the green ocean. Pink clouds parted to slide – pfft – over the edge of the earth.' Or as Hockney puts it, you hear 'the great crescendo in Siegfried's funeral music, and you'd come round a corner and as the music rose you'd see the setting sun suddenly revealed'. Obviously, he was *conducting* the whole expedition. This was a real-time, real-world parallel to the experiences he was creating with his opera designs: matching the music to a visual and spatial experience. He coordinated the landscape, the movement of the listeners in his vehicle, and the music. Unlike conductors whom he criticizes, he was getting the timing, the tempo, just right.

Hockney denies he has synaesthesia, the cross-referencing of the senses by which some people are able to experience sights and sounds together, so that, for example, the jazz pianist Marian McPartland could announce that, 'The key of D is daffodil yellow!' But nonetheless he is extraordinarily attuned to the ways in which sound, space, colour, and lines can fit together.

DH The Santa Monica Mountains drive was an hour and
a half long. I remember taking some kids on it and they
just said, 'Oh, this is like a movie!' They realized that the
landscape and the music fitted together, but they would
never, ever have listened to, say, the prelude to *Parsifal*
in a concert hall. But in movement, it was fantastic.

MG Of course, a lot of movie scores were derived from opera. The shot may be of John Wayne riding across the Wild West, but the music comes straight from Europe.

DH That's right. When Dimitri Tiomkin – who wrote the scores for lots of Westerns, including *Red River*, *High Noon*, and *Gunfight at the O.K. Corral* – got an Oscar for one of his films, he said in his speech, 'I'd like to thank Wagner, Puccini, Verdi, Tchaikovsky, and Rimsky-Korsakov.' Prokofiev did film music, and that was terrific too.

MG But, of course, recorded music – though it gives us pleasure – isn't the same as being at a performance.

DH Oh *yes*, *yes*. I hear through electronic things now. That's all I can do because of my deafness, so I don't go to concerts that much as I'm hearing it electronically. The great thing about concerts, I'd thought earlier on, was that it wasn't electronic. You could hear in a different way. That's how I discovered music.

MG There's a physical connection in a live performance, as there is when you are in front of a picture or sculpture. If someone is playing the violin in front of you, the air is vibrating as a result of their actions in the same space that you are occupying. Not only can we see *musically*, on your drives, in films, or when we watch an opera staged, we can also *hear* spaces.

DH If you think of it, the acoustics of a recording are the acoustics of another place – not those of the space that you are currently in. You are hearing it in a different room. That must set up a *distance*.

13

Lost (and found) in translation

DH I'm reading a lot now. I always have loads of books.
They are piling up here: books about trees, Julian Barnes's
latest book, *The Man in the Red Coat.* I've got one by a
young person about fungi, which he says are more animal
than vegetable. I thought, that will drive the Vegans mad!

If you reread novels when you are older, they are not
quite the same, because you have a slightly different point
of view. I'm just reading Flaubert's *Sentimental Education*
– for the *third* time. It's about this young man and an
older woman he falls in love with called Madame Arnoux.
I last read it at the time I was making the paper pools,
so in about 1978; I had read it first ten years before that.
Of course, Madame Arnoux seemed quite old to me then,
when I was about thirty. But reading it again, I realize that
she's much younger than I am now.

A lot of *Sentimental Education* is set in Normandy,
which is why I am rereading it. Flaubert himself spent
almost all his life in and around Rouen. His novella
A Simple Heart is set in Pont-l'Évêque, which is very near
here. That's a lovely story. In the early 1970s, I did some
pictures of it. For a while, I was thinking of illustrating it,
although I never did in the end. But I did do a few little
etchings. One was of the main character, Félicité, sleeping
with her parrot. In the story, she had only ever seen
a single book, an illustrated one about geography that
had pictures of a whale being speared and of a monkey
carrying off a young woman. She thought that that

Félicité Sleeping, with Parrot: Illustration for
'A Simple Heart' of Gustave Flaubert, 1974

*My Mother Today; as a Study for Félicité in
'A Simple Heart' of Gustave Flaubert,* 1974

was abroad, that all foreign places would be like that. Otherwise, she knew only a print of the Baptism of Christ with the Holy Spirit and the stained glass in the local church. I thought if those were the only pictures she ever saw, they would have been really *impressed* in her mind, wouldn't they? She would always have remembered them. So in a way Flaubert's story is very visual: it is about pictures.

> To start with, I used my mother to make a study of Félicité. This was in 1974, so she was about seventy and I was getting on for forty. At the climax of the story, Félicité is about seventy, so I thought that my mother would be a good model.

In other words, he produced two prints concerning the central character in Flaubert's novella. The first was explicitly a portrait, entitled *My Mother Today; as a Study for Félicité in 'A Simple Heart' of Gustave Flaubert.* Even this, however, is a specific kind of portrayal: a picture of a real person intended as a preliminary to a picture of a character in a story (and it has a characteristic acknowledgment of passing time in its title: 'My Mother *Today*', not as she had been the previous day or might be the following week). Then he made a more compli-cated, and wonderful, work, *Félicité Sleeping, with Parrot: Illustration for 'A Simple Heart' of Gustave Flaubert.* This was executed partly in etched line (Félicité's face and hand), partly in dark-grey aquatint (the maid's clothes), and partly in bright colours (the parrot). It is no longer a portrait, but still resem-bles Laura Hockney, his mother. You might say that she is now 'in character', like an actor on stage. The effect of using colour only for part of the image is analogous to the way certain film directors have moved between black and white and full-colour footage within a single movie. Andrei Tarkovsky, for example,

did this in *Andrei Rublev*, in which the scenes of life in fifteenth-century Russia were shot entirely in monochrome; the screen comes to chromatic life only at the very end, in a sequence showing Rublev's art: his paintings.

Félicité's life is isolated and limited. She is loyal, naive, and good-hearted, but everyone close to her dies or deserts her. The solace in her quiet existence is a pet parrot, Loulou, which is passed on to her by chance. After it dies, she has the bird stuffed and keeps him on a shelf in her bedroom. Everything vivid in her world – all hope, love, and happiness – is concentrated in the parrot. She had long confused her pet with the Holy Spirit, especially as depicted in a popular print of the Baptism of Christ, where, 'with his purple wings and emerald body he was the very image of Loulou' (which demonstrates exactly what Hockney meant: the power of an image, especially in the mind of someone who knows very few pictures). When Félicité is breathing her last, she has a vision, 'she thought she saw, as the heavens opened, a gigantic parrot hovering over her head'. With that statement, funny, grotesque, tender, and touching, the story ends.

DH Some years later my picture was used on the cover of Julian Barnes's book *Flaubert's Parrot.*

So there was another twist. Barnes's novel is a wonderfully subtle and paradoxical investigation of the shadowy zone between truth and fiction in which the central (invented) character tries to establish the relationship between Flaubert's own life and his fiction. In particular, he tries to track down the real stuffed parrot that sat on the great man's desk while he was writing *A Simple Heart.* But that piece of nineteenth-century taxidermy proves as elusive as the link between it and Loulou in the story – and indeed, the connection between Laura

Hockney and the woman on the cover who has her chin and mouth but now represents another, imaginary individual.

DH The reason I didn't go on with the illustrations was that I read that Flaubert absolutely *hated* illustrators.

It's not difficult to guess why Flaubert was opposed to having his works illustrated. He was indeed, as Hockney notes, an extremely visual writer; no doubt he wanted to create pictures in the reader's imagination with his words. The etching follows the description of Loulou the parrot precisely: 'his body was green, his wingtips pink, the front of his head blue, and his breast gold'. But the print translates the essence of Flaubert's text into completely different terms: line, form, tone, and colour.

*

Long before I met him, Hockney made a thought-provoking remark. 'There's no such thing as a copy, really. Everything is a translation of something else.' We normally think of translations as being between one language and another. But there are many varieties of translation or transposition. Changing from one visual medium – from drawing to painting, say, or from lithograph to etching – is translation of sorts. Each of these media, as he points out, has different possibilities and limitations. You cannot do the same things in a woodcut as you could in an aquatint. Hockney himself likes to ring those changes, moving from iPad to easel, from small-scale work on paper to large canvas. Sometimes, as with the drawings and paintings of the lily-pond, he makes versions of the same or similar images in different media.

Adapting a written story for the stage or cinema, so that living actors play the parts of the characters, is also a kind

of translation. So is transforming a story into an opera or ballet so that the plot and emotions are expressed in sounds and rhythmic movement. One can imagine *A Simple Heart* as a film or a musical, but of course it would then become a different thing, of which Flaubert might well not have approved. An operatic version would certainly not be the same, but it could have its own merits. Today, more people love to listen to Gaetano Donizetti's mesmerizing *bel canto* masterpiece *Lucia di Lammermoor* from 1835 than read Walter Scott's historical novel *The Bride of Lammermoor* of 1819 on which it was based (though the latter probably still has its admirers).

DH The other day, I was looking at Hans Christian Andersen's fairy tale 'The Drop of Water'. It's about an old magician called Kribble-Krabble, who magnifies a drop of water from a puddle and colours it pink with a drop of wine, so all the little bacteria and creatures in it look like people.

This is a parable likely to attract Hockney, with his lifelong fascination with colour, transparency, water in general, and puddles in particular. The moral is that this tiny world is a microcosm of the larger, human one. Kribble-Krabble shows his dyed droplet to another magician, and asks him what he thinks it is. 'Why, one can see that easily enough', he replies. 'That's Paris, or some other great city, for they're all alike. It's a great city!' 'It's a drop of puddle water!' says Kribble-Krabble.

Hockney is fond of another of Hans Christian Andersen's tales, 'The Nightingale', which was the basis of Stravinsky's short opera *Le Rossignol*, for which he designed stage sets and costumes in 1981 when it was part of a second triple bill at the Metropolitan Opera in New York. The plot of this fable is reminiscent of *A Simple Heart* in that it also involves a splendid but inanimate bird.

Emperor and Courtiers from 'Le Rossignol', 1981

After designing the Met production, Hockney published a little book in which he retold the tale of 'The Nightingale' in his own words and reproduced some of his designs. What he did in the images, and also in his narrative, was to clarify and simplify. The designs were done at the time at which he fully realized the beauty of 'French marks', and consequently they have a flavour of Matisse and Picasso (suitably enough, since Stravinsky's opera dates from 1914, the absolute climax of the Cubist and Fauvist eras). In Hockney's version of the story, the floweriness of the original is pared down, and acquires a casual contemporary charm:

'The emperor of China lives in a porcelain palace.
Everything about the palace is beautiful. The flowers
in the garden have such a subtle perfume that little bells
are hung on them, just in case you don't notice. All the
travellers who come to the kingdom write about how
beautiful the palace is. And the poets who come say the
most beautiful thing of all is the nightingale that sings
by the seashore.'

A search is made to find this wonderful bird, 'but the only one who knows about it is the little girl who washes dishes in the kitchen'. Eventually the courtiers track it down but, Hockney recounts, 'when they discover it's just a rather plain little bird in a tree, it's a bit disappointing':

'Just at this moment three ambassadors from the
emperor of Japan arrive with a present – a mechanical
nightingale. It isn't a Sony or a Panasonic; it's old-
fashioned clockwork. They open the box and wind it up
and everybody's quite delighted. It sings away. Everyone
thinks it's quite lovely, but it's actually garish and

hideous compared to the real one. But they like it, and of course when it's wound up it always sings the same way.'

Until, that is, it winds down and can't be wound up again. And when the Emperor falls ill and Death comes for him, it is only the song of the real, little brown bird that charms him away. So the next morning, 'all the courtiers, expecting to say fare-well to their emperor in a room of darkness, are startled when they come back into his room and the emperor is sitting up in his bed and he greets them cheerfully. The room fills with light and everyone is amazed.' That last touch, the transformation from darkness to light, is not Andersen, nor Stravinsky. It's purely visual: Hockney's transformation of a literary work, which had already been transposed into the musical idioms of harmony, rhythm, and melody into dramatic terms that the audience could see and immediately comprehend.

'The Nightingale' was not Hockney's first imaginative encounter with a fairy story. More than a decade before, in 1969, he had produced a remarkable book: *Six Fairy Tales from the Brothers Grimm*. This was, he pointed out, just as important a work as a major painting, and had required quite as much time and effort. To begin with, he read the whole collection of stories made by the Grimm brothers, some three hundred and fifty in all. A few years later, he explained what drew him to this anthol-ogy of time-honoured northern European yarns: 'They are fascinating, the little stories, told in a very, very simple direct language and style: it was this simplicity that attracted me. They cover quite a strange range of experience, from the magical to the moral.' His final selection of six tales to illustrate was made partly on visual grounds, though somewhat per-versely, since it might be the difficulty of translating an episode into lines and marks that attracted him: 'My choice of stories was occasionally influenced by how I might illustrate them.

The Glass Mountain from 'Illustrations for
Six Fairy Tales from the Brothers Grimm', 1969

For example, Old Rinkrank because the story begins with the sentence: "A king built a glass mountain." I loved the idea of how you drew a glass mountain. It was a little graphic problem.' There is a clue in this to the qualities that appeal to him, and which in turn attract many people to his work: a seamless blend of the sophisticated and the straightforward. That's true of the drawings he's doing right now.

DH I've just finished Jackie Wullschlager's biography of Hans Christian Andersen. It's very good. I've always loved his stories, but I didn't know much about his life. Apparently, his mother didn't read at all. He was born in 1805. Well, in 1805, my ancestors were agricultural labourers in Lincolnshire and East Yorkshire. They probably wouldn't have read anything. And they wouldn't have seen many pictures either, especially in England, as Cromwell and the Reformation had got rid of most of them, even in the churches.

So there is a link between Andersen's background and Hockney's own – and also, for that matter, with the inner world of Félicité in *A Simple Heart*. According to Flaubert, of the religious dogma and liturgy she heard in church, 'she did not understand, did not even attempt to understand, a single word of it'; but the picture of the Holy Spirit, a supernatural bird standing for love, goodness, and hope, meant everything to her. It was 'really *impressed* in her mind'. Of course, Hockney's whole life's effort has been to create pictures that make an impact like that.

DH After all, most don't. Most images are just forgettable.

14

Picasso, Proust, and pictures

DH I've started painting now, but I'm not going to give up these iPad drawings because you can make wonderful textures if you build them up with layers. We're now thinking they should be printed out quite big, except for the still lifes, because when we printed out the rain on the pond big, you could see all the marks. And it's all about mark-making, isn't it? We're going to arrange the printed-out pictures of spring in two rows, with a large one occasionally taking up both rows. It's going to be about forty metres long, and you have to walk past it like the Bayeux Tapestry. It'll be quite a long walk, and there's a narrative, isn't there? If they were hung in one long line and people stood two metres apart, because of the virus, they could walk along it and it would be much longer even than the tapestry. It would be a *cumulative* experience.

Hockney likes to quote Cézanne's dictum, 'A kilo of green is greener than half a kilo', which is true of colour, but also of almost everything else. A larger scale makes a difference. But so does a shift in texture, or in context, and of course position in a sequence. Thus a hundred landscapes in a row would have a different effect from one alone, because each one would add to what had already been seen. Hockney has long been intrigued by the way that a succession of pictures can add up to a narrative. Initially, he made images that paralleled existing stories, such as his print series *A Rake's Progress* (1961–3) and *Six Fairy Tales from the Brothers Grimm*. Subsequently, he realized that

The artist in his studio at La Grande Cour, with some of the
iPad works printed at large scale, August 2020

there did not need to be such a starting point; a series of pictures could constitute a narrative of its own, though it might not be the kind of plot that would underpin a work of literature. This idea seems to have come to him one day as he was leafing through a multi-volume compendium of Picasso's works.

DH The Zervos catalogue of Picasso's paintings is fantastic! I've looked through the whole thing from beginning to end three times. It takes some doing, but it's a wonderful experience. It doesn't bore you. The catalogue raisonné of a lot of artists *would* bore you, if there were thirty-three volumes of it. People might think it's not meant for looking through like that, but it can be. If Picasso did three things on one day, they're numbered one, two, and three, so you know what he did in the morning and then in the afternoon. It's like a visual diary. In April 1984, I gave a talk about thirty-five paintings that he did in ten days in March 1965, which I said made up *one* work of art. And when I delivered it, I didn't read from a text. If someone reads a lecture and you're in the audience, you ask yourself why you're there – you might as well have just read it yourself. But someone delivering a talk with an interest and an enthusiasm, that's the difference, isn't it? The audience can tell you're enthusiastic from the tone of your voice. I did the talk first at the Guggenheim in New York. When I did it in LA, Robert Graham, the sculptor, came up to me and said, 'Tell me, did you have some cocaine before you did that talk?' I said, 'No, I wouldn't dare, because I might go on for longer!' But he thought I had, because of the way I was talking away.

Typically, although his career as a lecturer was a short one, Hockney had quickly grasped the essence of the genre: that it is

a variety of performance, and one best delivered ex tempore, even if you are following a mental script. Equally characteristically, he was excited by his discovery that a number of pictures might have an internal storyline quite distinct from any that already existed, or perhaps could exist, in words.

Thanks to the meticulousness of the Guggenheim Museum's archiving system, and the ubiquity of information in the contemporary world, at the click of a mouse it is possible to listen to him giving that talk, which was entitled 'Picasso: Important Paintings of the 1960s', on that day nearly four decades ago. He began by extolling the Zervos catalogue, which he had read like a novel (and is still lined up on the bookshelves in the sitting room of his Los Angeles house):

'It's an incredibly unique document, because, from
a very early period, Picasso dated everything....
You can look up and find out what he was doing on
Thursday afternoon of June 23, 1939 or something.
You can actually find out.'

Hockney then began to discuss the individual paintings that Picasso made in that extraordinary ten-day spell, each of which shows an artist painting a woman, and what they meant to him.

'In each of these thirty-five pictures, the painting of the
woman, the invention of the way of seeing, is staggering,
actually, because each time, it's something different....
So what we see is an artist with his model, a woman. He
shows us her one way. Then the artist is sitting down....
I think it's telling us that every time he sees and looks at
the woman, of course, you can see something different.
There are so many aspects.... They're also about the
canvas, the empty canvas, the problem of depiction, the

Pablo Picasso, *Painter at Work*, 1965

problem of representation. It's why Picasso never goes to what we would call the abstract. He suggests there's no such thing; it's always a depiction of something.'

He then speculated about the meaning of one particular canvas, in which the depicted painter has put his brushes down and is merely looking at his female sitter.

'It can be interpreted many ways. But after all, an artist is looking constantly. It's also about an artist having to see, having to look. Going back, as it were, constantly, to nature. I think Picasso does that, which is why the art is open-ended.'

Hockney was correct in arguing that the great Spaniard's work is full of hidden anecdote. Picasso admitted that he enjoyed 'no end inventing these stories. I spend hour after hour while I draw, observing my creatures and thinking about the mad things they're up to.' Plainly, Picasso contemplated himself and thought about what he was doing, as he did in *Painter at Work* (signed and dated '31.3.65'). And clearly, Hockney looked at Picasso and saw himself – or a way that his life and career could develop. This, perhaps, is the source of his predilection for producing works in groups that together add up to *one* work of art. That's true of much he has done in the last decade: the various 'Arrivals of Spring' in 2011, 2013, and now 2020, but also *82 Portraits and One Still Life* (2013–16). He has come to think of pictures as fitting together into these larger wholes.

DH People usually write about exhibitions *before* they open, for catalogues and so on, but it's always a lot more interesting to do so afterwards. When the curators are putting them together, they go and see paintings individually, but a lot

of the time they are looking at photographs. Then they write their essays. But curators have said to me that it's only when you put the exhibition together that you can actually learn something, meaning that you are looking at the work *collectively*.

On the other hand, any narrative that emerges from a painting or drawing is open-ended. It seems that even Picasso had to use his imagination to work out what the figures in his pictures were up to, and was sometimes surprised himself.

DH Everybody's looking at the same picture, but they don't necessarily see the same things.

*

DH I'm reading Proust's *Remembrance of Things Past* again at the moment. This is the third time I've read that too. Jean Frémon brought me a set of the translation by Scott Moncrieff. I've just begun it. Actually, I'm reading the *Sodom and Gomorrah* part, so I'm beginning in the middle.

In his early autobiography, Hockney described his first encounter with Proust. It took place during his period of National Service, which, since he was a conscientious objector, he spent working in a hospital near Hastings. It is the one period of his life during which he did very little work as an artist as he was kept busy by his duties as an orderly:

'I read Proust for eighteen months, which is probably another reason why I didn't do any work. I made myself read it because at first it was much too difficult. I'd never been abroad but I'd been told it was one of the great

works of art of the twentieth century. I'd read from
an early age, but mostly English. So long as it was
about England, I had some sense of what it was about.
Dickens I'd read and you had some sense of what it was,
but Proust was different.'

The reason why Proust's novel had the reputation of being a
great modern work of art was because it deals with the relativ-
ity of time and of perception. Everything is seen at a particular
moment and from a particular angle. The entire vast, seven-
volume novel has little plot in a conventional sense, although
love affairs, social gatherings, and journeys take place. It is
rather a series of moments, and the climax comes when the
narrator grasps how the intricate mosaic of his life fits together.
It is, as Hockney has said to me, essentially a Cubist way of
looking at the world, integrating numerous points of view and
instants of time into a whole.

The novel is also highly visual – another Hockney point – in
that Proust, though he wrote in words, seems to have thought
frequently in pictures. In his book *Proust's Binoculars*, the liter-
ary scholar Roger Shattuck noted how frequently the novelist
describes human experience and thought by using the word
'image'. But he divides this simple term into a series of more
specific metaphors such as *photographie*, *épreuve* (proof), *cliché*
(negative), and *instantané* (still or snapshot).

These are all ways of referring to a fragmentary impression
or memory. So too is the most elementary, the word '*pan*'
meaning 'side, section, spot'. At the start of the novel, Marcel,
the central character, can recall no more of the village of
Combray, scene of his childhood, than '*un pan lumineux*', an
illuminated area something like a magic-lantern slide of the
house he lived in and its occupants. In a later volume, the writer
Bergotte dies in front of Vermeer's *View of Delft*, which he

Mother I, Yorkshire Moors, August 1985, 1985

has gone to see in a gallery having read in the newspaper of a
'petit pan de mur jaune' – a little patch of yellow wall – that is
described as a 'priceless specimen of Chinese art, or a beauty
that was sufficient in itself'. In effect, this is a brush-mark, the
kind of touch that Monet might have applied to one of his hay-
stacks, or Hockney adds to a painting or iPad drawing. It is a
note of colour that makes the picture sing, that works for visual
reasons that defy verbal analysis. Braque once remarked that
in art it is possible to explain everything except the little bit

that counts. The '*petit pan de mur jaune*' stands for that inexplicable extra factor.

Proust's perspective, however, was more than just a matter of almost abstract notes of colour. One of his insights was much the same as Hockney's often expressed observation that 'we see with memory'. That is, we don't experience a sight in a fraction of a second, as a camera-shutter does. Our eyes are connected to our minds (another refrain of his) and therefore we understand what we are seeing now in terms of what we have seen before. That's why Proust thought that it was only possible to understand something or somebody through a series of images from differing moments. Hence, the character Marcel's reflections on a fresh insight into one of his acquaintances:

> 'M. Verdurin's character offered me a new and
> unsuspected aspect; and I had to concede the difficulty
> of presenting a fixed image of a character as much as of
> societies and of passions. For character changes as much
> as they do, and if one wishes to photograph [*clicher*]
> its relatively immutable aspect, one can only watch as it
> presents in succession different appearances (implying
> it does not know how to keep still, but keeps moving) to
> the disconcerted lens.'

That is a literary and psychological equivalent to one of the photocollages that Hockney made in the 1980s, constructed from numerous shots of the subject taken at different times and from varied angles. He is in fact a highly Proustian artist.

MG There's perspective in time, isn't there, as well as space? You see everything from a point of view, which is *here* but also *now*. These days you are reading the novels as an inhabitant of France, living in some of the very areas

in which Proust's scenes are set. On the other hand,
in 1957 you were a bit closer in time to the period Proust
was writing about than we are now to the 1950s.

DH Lots of Proust is set in Normandy. He was driven here in
a sealed car – because of his asthma – to see the orchards
in bloom. A sealed car! [laughs] Last summer, we went
up to Cabourg on the coast (which is called Balbec in the
book) and had dinner in the Grand Hôtel, where he once
lived; it was with Catherine Cusset, who has written a
novel about my life. There's a text framed on the wall from
Proust's second volume, *Within a Budding Grove*, in which
he described the fishermen and workers looking into the
dining room from outside, squashed up against the glass.
He wrote that it resembled an aquarium, and the poor
would peer in at everyone dressed up as if observing
another species. The habits of the rich were as strange to
them as the lives of fish and lobsters. The hotel and the
sea haven't changed since 1907. But these days the people
outside are dressed the same as those inside, just about.

MG So the architecture is the same, but the world around it
has altered utterly.

DH Yes, it's true we change too, or at least our viewpoint does.
There's a distinct change in my drawing, because I'm here
in Normandy. That applies to time and your age too. The
other day I was saying to Celia that her grandchildren,
who must be eighteen or twenty, look terrific. Everyone
of that age looks terrific to me now. When I was twenty,
I didn't think so. But age itself is changing with time, or
what counts as old. I remember my aunt saying, 'I'm very,
very old now' – but she was only about fifty-five.

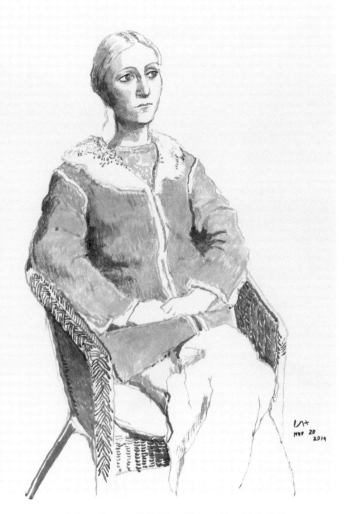

Scarlett Clark, 20 Nov 2019 (Celia Birtwell's granddaughter), 2019

15

Being somewhere

DH It was lucky that we were here when lockdown began.
I've just worked away. We don't see anybody. It's fantastic
for me. I think we've been a lot more creative. If people had
been coming and going, we wouldn't have done all these
drawings and the animations, but we're not disturbed.

I always planned to be here and doing just what I am
doing. But probably lots of people in other places are
observing their surroundings at the moment – and
drawing them too. I get drawings sent to me on Twitter
from people who are looking at my work and trying to do
something similar. There are kids doing it too. And some
are very good. David Juda [an art-dealer friend] told me
that he was going for a walk on Tooting Common today,
because it was a lovely day and the blossom was out. But
he wouldn't normally have thought of going there. Celia's
just staying at her cottage, but she says it's the first spring
that she's really observed. People are *looking* at things.

Once while I was talking to the American abstract painter
Ellsworth Kelly in an unremarkable office off Madison Avenue,
he started pointing out the sort of sights that gave him ideas
for pictures. Gazing at the utilitarian blinds and shelving, he
exclaimed, 'Look at that shadow in the corner! There's some-
thing going on there!' As soon as he had said that, I could see in
other tiny, apparently insignificant details the germ, perhaps,
of a painting by Kelly. Similarly, one day Hockney must have
noticed a tree with low branches, on which a few stray blossoms

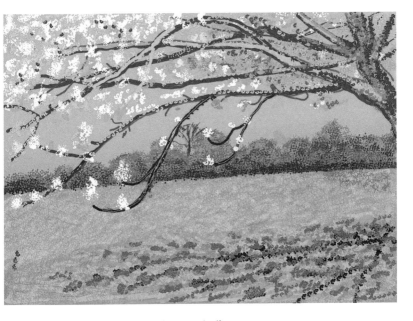

No. 187, 11 April 2020

sprouted here and there, and became interested in the pattern of shadows that the tree was throwing on the newly mown grass, and the way space extended back in steps: first to the hedge, then to the row of trees behind, then to the sky – and then presumably, like Kelly looking at the Venetian blind, he thought to himself, 'There's something going on there!'

Hockney's friend Jonathon Brown has known him for more than forty years, and a long time ago David said something casually that struck him as significant: 'I don't need to be any-where.' By this, Jonathon understood him to mean that he felt he did not have to be anywhere *in particular* in order to work; and indeed, over the years he has painted and drawn in a large number of diverse places throughout Europe, America, Asia, and north Africa. But Jonathon associated this free-and-easy approach to location with a further, more audacious thought: everywhere is interesting to David.

More than once, Hockney has mused that van Gogh could have been locked in the most boring motel in the United States – a Spartan single room in Tulsa, say – with his paints and easels. And after a couple of days, he would have emerged with some beautiful, rivetingly memorable pictures. In fact, this is only a slightly exaggerated statement of what actually did happen in Arles, where Vincent found himself living on the scruffy urban outskirts of the town – the zone in which these days you would find the launderettes, convenience stores, and car-tyre outlets. Many of his subjects were the nineteenth-century equivalents of those mundane places. He painted the bridge over the railway line; goods wagons on a siding; a thoroughly nondescript municipal park; the street outside his little house being dug up so a gas main could be laid. Even the agricultural plain where he went to paint the countryside, the place depicted in the majestic, glowing scenes of harvest, would, as Hockney points out, look flat and dull in a photograph.

This applies to Hockney's own work too. The fields and woods he painted in Yorkshire, though pleasant enough, were no more striking than (and quite similar to) thousands of other corners of rural Britain. In some respects, a spot that is already renowned – what Walter Sickert used to call the 'august view' – presents more difficulties than an ordinary stretch of nowhere in particular. Monet's reaction on arriving in Venice for the first time was that it was absolutely impossible to paint: too beautiful, and also already done by everyone from Canaletto to Whistler. He overcame these feelings; and Hockney, too, has tackled some august subjects: the Grand Canyon, for example, and Yosemite. But in recent years he has dwelt more on what Constable termed his 'own places', in East Yorkshire and now his four acres of northern France. What is special about these landscapes is precisely that they are his own: long studied and internalized. He knows them deeply, thoroughly, intimately, and gets to see and understand more and more with each hour of attention. Bit by bit, these familiar spots turn out to be micro-cosms containing all the ingredients a painter could require.

The moral is this: it is not the place that is intrinsically interesting; it is the person looking at it. Wherever it is, it will be part of the world; the laws of time and space will still apply. The sun will rise and set, and so will the moon. Even a certain light or a particular shade of colour can make something appealing to an artist (and perhaps only that artist: not many people would have been as inspired as van Gogh was by the railway bridge or civic gardens of Arles).

DH Everything is here! Every kind of tree – apple, pear, plum – and you see the sky all around you. The sky is amazing. There are great *big* white clouds sometimes, *rippling* white against the blue. I think these iPad works are much better than the last lot I did. There is more

John Constable, *Flatford Mill from a Lock on the Stour, c.* 1811

detail in them; I've done it more thoroughly. In 2011,
I had had an iPad for just six months when I did the first
Arrival of Spring on it. But this spring of 2020 is much
more detailed. As I've said before, I'm living in the middle
of my subject here, and that makes a great difference
because I get to know the trees a lot better.

The same was true of John Constable and East Bergholt, his
native village on the Suffolk–Essex border. He'd lived in the
middle of it, observed it endlessly. As a boy, he had sat beside
the river fishing for hour after hour. Catching fish with a line
is an activity that, though perhaps not kind to the animals,
requires the closest attention to minute signs – the movement
of the water, a ruffle on the surface, the shadow of a cloud – that
may prompt your prey to rise. To succeed, as Giuseppe Penone,
another youthful angler turned artist, has noted, you need to

understand how fish *think*. And indeed much more than that, how the landscape works together: the weather, the river, the vegetation, and the living creatures.

I've been thinking about Constable often recently as I pace across the water meadows on my daily constitutional – partly because this is an East Anglian landscape: flat, leafy, watery, abounding in willows. Of course, it is difficult now to see such terrain without thinking of the artist's name. But it is also because he showed how much visual pleasure can be extracted from such a small acreage. The entire area of East Bergholt, Flatford, and the adjoining stretches of the River Stour is no larger than the zone of riverside Cambridge where I stroll around – probably smaller – and not much more extensive than Hockney's Norman domain, yet out of this rustic corner he got picture after picture, many of them great masterpieces.

Before his marriage, Constable returned regularly in early summer from London to East Bergholt. Almost always when he wrote from there to his wife-to-be, Maria Bicknell, he exclaimed that Suffolk, was 'in great beauty'. His enthusiasm was never more eloquent than on 22 June 1812, when he declared: 'Nothing can exceed the beautiful appearance of the country at this time, its freshness, its amenity – the very breeze that passes the window is delightful, it has the voice of Nature.' That's just the sort of thing that Hockney exclaims, expressed in the idiom of the Romantic era. Some painters like Turner travel the world in search of new views. But others are what Constable, with seventeenth-century Dutch masters in mind, called, '*stay-at-home* people'. He was a stay-at-home person. He never went abroad, even refusing to go to Paris to receive a medal for painting from the French king, Charles X. Almost all of his greatest works are of the few locations where he lived or which were connected with those he loved: East Bergholt, Hampstead, Salisbury, Brighton. They were his places.

Similarly, those greens and commons in Cambridge are among my places. I have walked across them many hundreds of times. Nonetheless, Constable helps me to see them, just as he got hints from earlier painters such as Jacob van Ruisdael. 'We derive the pleasure of surprise from the works of the best Dutch painters', he explained, 'in finding how much interest the art, when in perfection, can give to the most ordinary subjects.' This is exactly Hockney's point about van Gogh and the motel.

DH I've told you what Rembrandt said to his students: do not travel, even to *Italy*. Of course, getting over the Alps was quite a job in those days. Now you just look down on the mountains from a plane. Well, I don't mind staying here. I am getting on with lots of things. I will always remember the spring of 2020. The weather is marvellous. It rains some days, but the *rain* is beautiful. I'll carry on because the apple trees are only just now turning green and the fruit's just appearing a little bit. It's still *spring* green here.

*

Of course, although anywhere can be equally inspiring, it is not the case that you will find exactly the same conditions everywhere. Changing place makes a difference. It does so partly because each tiny patch of the Earth's surface on which our gaze may fall is subject to the laws of physics and chemistry, which will apply in an infinity of varying ways. The angle of the sun's rays alters according to the degree of latitude, north and south, at which you are standing and the time of day and point in the year. In *How to Read Water*, Tristan Gooley explains how even in the case of a humble puddle, that favourite subject of Hockney's, its position will be determined by all manner of factors, such as the underlying geology, the lie of the land, the

Woldgate, 6–7 February 2013, from *The Arrival of Spring in 2013 (twenty thirteen)*, 2013

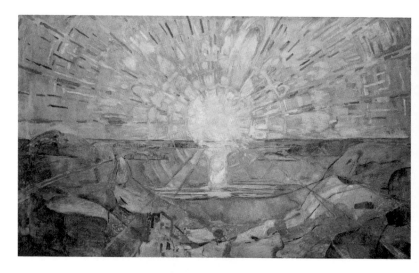

Edvard Munch, *The Sun*, 1910–11

prevailing wind, whether or not the place is shaded from the midday sun (which in the northern hemisphere will be to the south). The pattern of ripples on the puddle's surface will respond to the smallest and largest disturbances, a drinking bird and a passing bus; it will contain its own little community of small organisms, all adapted to subtle variations in temperature and soil acidity; and so on and on.

Thus it is not only that a puddle may reflect the wider world – the sky, the stars – it is in itself a miniature version of much larger phenomena: lakes, rivers, oceans. However, this obviously does not mean that you will see the same things in all of these places. On the contrary, everywhere will be different in its own way. Take for example, the height of the sun and the length of the day. One July, years ago, I was sailing off the Baltic coast

of Latvia. This wasn't quite the land of the midnight sun, but we were close to its frontier. The sun did dip below the horizon for a while, at perhaps two in the morning, but sunset and sunrise went on and on. Each night there was an aerial display of reds, pinks, gold, and purples in the sky, for hour after hour.

It made me wonder whether Mark Rothko's Latvian childhood had had a deep effect on his imagination. Rothko was an American citizen, and a leading member of the New York School of Abstract Expressionist painters. He left Russian territory, never to return, in 1913, when he was ten. Yet there are reasons for thinking that his art and imagination were deeply influenced by those early years. He was born Marcus Rothkowitz in the city of Dvinsk, which was then part of the Tsarist empire; it is now the Latvian city of Daugavpils. This is a place of forests and wide horizons on the Daugava river. The winters are long, dark, and hard – Rothko remembered skating to school – and in midsummer, the sun sets for only three hours a night. In a poem, he associated heaven with a light shining through mist. To a fellow painter, Robert Motherwell, Rothko extolled the 'glorious' Russian sunsets of his childhood.

DH Further north, the sun doesn't set really at all. It goes down to the horizon, stays there, then starts moving up again. I've seen that in the north of Norway, and I've seen the aurora borealis there as well. And I noticed those circles round the sun that Edvard Munch painted; you can see them. There aren't only rays – there are also these circles just like the ones in his pictures: lines in it that cameras could never see, but we could. Of course, in Oslo in June, Munch could have looked at the sun for a lot longer than van Gogh could have in Arles.

We went twice to Norway, once to Bergen, and then to the most northerly part, a bit south of Spitsbergen.

It is like the edge of the world. There's a big window, and you stand and watch the sun come down and go up in this mist with all these people walking silently there. It's a spectacular place, but totally treeless. I did quite a few paintings there. It's either permanently light or permanently dark. When people went to the North Pole, they wouldn't have had a night at all if they had gone in the summer. In the winter, it's *all* night.

In East Yorkshire too, you can see a lot of sky because there are no hills, so you can watch the sun setting and rising. The skies there are really big, though not quite as big as the American West, where you can see for miles and miles. Here in Normandy, on 21 June, midsummer, which was last night, you can't quite see the sunset because of the hills. But you can see the sun rise from the kitchen window, and when it does, you get that little gold bar when it first comes up. When the sun sets, it's over the hills to the west of the house so you can see it going down so far. Of course, in any seaside place, you'll have that lovely marine light. Bridlington had that because it was reflected from the sea. The studio I had there was very light because it was so close to the coast. The sea light goes inland for about a mile, because that's how far the reflection from the sea goes, then it fades. Here we're about twelve miles inland.

The sunsets and sunrises of Bridlington prompted numerous ravishing drawings, just as the ones visible in Normandy are right now. In some cases, Hockney – not unlike Ellsworth Kelly – noticed some intriguing interaction between the sun and the Venetian blind in his bedroom.

*

No. 187, 17 June 2010

Constable had powerful, almost amorous, feelings about trees. On 5 June 1814, he confessed to Maria, 'I love the trees and fields, better than I do the people' (though he made an exception for her). When, at a lecture in 1836, he described the sad end of an ash – in his words, the fate of 'this young lady' – he sounded positively bereaved. He then showed a drawing that he had made 'when she was in full health and beauty'. He went on to narrate how, passing by some time later, he discovered that 'a wretched board had been nailed to her side, on which was written in large letters, 'All vagrants and beggars will be dealt with according to law.' The poor ash 'seemed to have felt the disgrace' as her branches had begun to wither. When Constable next saw her, he recounted, she had been cut down to a mere dead post, just high enough to support the notice. 'It is scarcely too much to say that she died of a broken heart.'

DH We've realized that next year, during March, April, and May, we don't want any visitors because that's the most active time. Next spring, I think I might concentrate on the cherry tree. Just draw it every day. Once the little changes begin, I could probably draw it every day. [He must love that cherry tree, and the dying pear trees whose branches look like clapping hands and all the rest, as Constable loved his ash.] You should paint what you love! I'm painting what I love; I've always done it. I'm going to stay here. I'm not going back to America for a while. I've done a hundred and twenty drawings of the spring in the grounds here. I didn't leave for three months. Now I'm going to do the whole year – and next year. I began last February and I'm going to go on until the end of January, so I'll get a whole year. I know that when I'm drawing the winter trees next year, they'll be drawn a bit differently, because I've developed the drawing a lot.

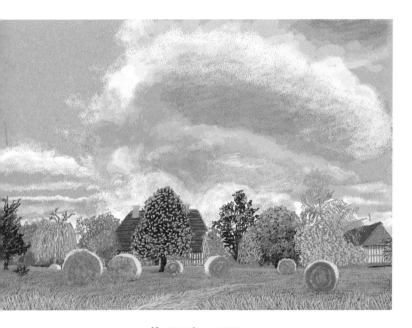

No. 472, 3 August 2020

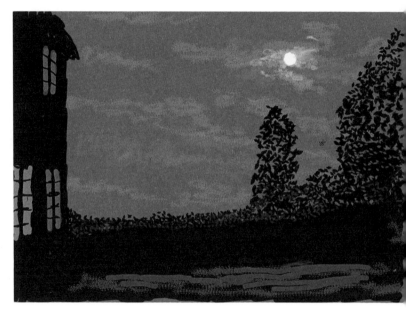

No. 592, 31 October 2020

16

Full moon in Normandy

DH Tomorrow night there's a full moon and if it's clear, I'll
do some drawings from outside in the moonlight. I might
even go down to the river to see what that looks like by the
light of the moon. This one is called a 'blue moon', I think.
There's a saying about that.

MG ... and a song, a jazz standard.

Hockney's enthusiasm is infectious. The following evening was
Halloween, and I found myself standing in the garden staring
upwards. It was indeed a splendidly bright and big-looking orb
that rose above the rooftops, though it was not of course blue.
Apparently, it is possible in very unusual atmospheric condi-
tions for the moon to be tinged with colour, but the logic of the
expression has been turned around. A blue moon means an
unusual one, in this case the second full one in a single moon.
It didn't last long over Cambridge, though. After a short while,
a veil of hazy cloud blew across like a curtain. The wind must
have been coming from the west, because in Normandy the sky
stayed clearer for longer. For hours on that chilly evening,
Hockney was outside on the lawn, drawing, drawing, drawing.
Much later, my phone rang.

DH Did you see the pictures of the moon I've been sending
over? It's now disappeared because there's too much cloud,
so I am going to lie down for a couple of hours and hope it
will clear up later when it gets over the pond. All of the

pictures so far are from just outside the door. I've drawn every full moon since March, I think. This time we kept the house lights on; I liked them like that because I was outside sitting in a chair. When I saw them, I thought, 'Oh, that's good!' The light from the door and the windows catches to the edge of the tree, and I got that in.

MG The house with illuminated windows and the moon above has a Japanese feeling somehow, and the moon reflected in the pond is a wonderful motif too, like a haiku. It's a very Japanese thing to get excited over the full moon; and in Japan, of course, autumn is considered the ideal time for moon-watching. The glow from the windows give the picture a cosy seasonal feeling too: you associate a lighted house at night with winter.

DH Yes, in summer you only put the lights on at nine or ten, and at that time of the year I was already in bed, because I was getting up at five-thirty or six to do the sunrises.

*

Hockney is still carried along by those gusts of enthusiasm. Now it is the moon, his little pond, the stream at the bottom of his meadow, and the autumn leaves, some still on the branches, some fallen on the lawn. Earlier in the year, it was the harvest, then the sunrise and sunset, then the spring; and before those, many, many other things, far too many to mention, going back more than sixty years.

The ancient distinction between the fox and the hedgehog – 'a fox knows many things, but a hedgehog knows one important thing' – does not really apply to him. Hockney knows one big important thing: how to make pictures. But his dedication

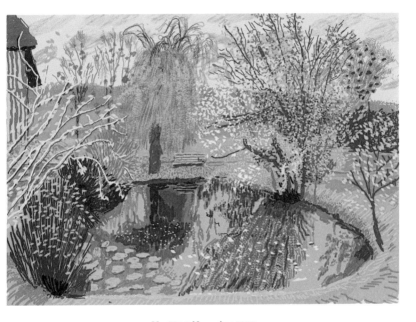

No. 599, 1 November 2020

to that activity has taken him in innumerable, diverse directions: into film, photography, digital drawing, an encyclopaedic range of print media, and towards a fresh sense of art history too – a reconfiguration of old-master painting and modernism. All major artists teach us how to see the world in a fresh way. Hockney certainly does that, but he is rarer in the degree of clarity with which he does so, and consequently in his ability to cut through. This is a natural, integral part of his personality and his work. He loves lucid intelligibility in line, form, and composition. All of which give his pictures a capacity to ring out across a room, and – more than that – to jump over the gallery wall and communicate with a huge number of people in the wider community outside the art world.

He can do that in words too. His interests are, after all, quite specialized, even esoteric. He is the sort of person who can happily spend five hours just looking at an exhibition of paintings, and who for recreation, after spending a day drawing, might read Proust or Flaubert or zip through a seven-hundred-page study of Wagner's cultural influence. But when he speaks, even about such subjects, he does so with such simplicity and ease that almost everything he says, journalistically speaking, is highly quotable. At the same time, by arranging his appearance in the way that he likes – as he would a picture – Hockney has acquired an easily identifiable image.

As a result – without, one suspects, trying too hard – he long ago became a famous person in mass-media terms. No doubt this has been useful, as well as having its disadvantages (the interruptions, the inroads into the tranquillity required to draw and paint). The winning of fame, however, was never really his motive; rather, it was a driving fascination with pictures, and through them with the world. In the manner of Jiro Ono, the sushi chef supreme, he just keeps on doing the same thing, continually fired by the urge to do it differently

and better. All his pictures, not only the ones of the surface of the small pond beside his house, mirror the world and demonstrate how beautiful it is. In this last remarkable couple of years, and especially during the strange seasons of pandemic and lockdown, he has managed to find more and more in less and less. Like other notable artists, especially the ones who keep going and growing, he is teaching us a lesson not only in how to see, but also in how to live.

MG You've had a tremendously productive year, even by Hockney standards.

DH Yes, I have, and I think it's some of my best work as well. Every time I go out, I see something to draw. I just look somewhere and I start. I've just done the pond, again. I'll show you very soon. It's not finished yet. In nature, as I've said before, it's all in flow; in fact everything is flowing, other than the lockdown. And I can draw and paint it here, especially with the rippling river. I know how to do the water now, I am watching it bubbling. I'm staying here for another year and another spring, summer, and autumn.

J-P [passing by] Don't listen to him. He's going to do the next ten years!

No. 602, 2 November 2020

Bibliography

Clark, Timothy (ed.), *Hokusai: Beyond the Great Wave*, exhibition catalogue (London: Thames & Hudson, 2017)

Constable, John, *John Constable's Correspondence*, Vol. II ('Early Friends and Maria Bicknell'), edited by R. B. Beckett (Ipswich: The Suffolk Records Society, 1964)

Csikszentmihalyi, Mihaly, *Flow: The Psychology of Happiness* (London: Ebury Publishing, 2002)

Flam, Jack, *Matisse on Art*, revised edition (Berkeley, CA.: University of California Press, 1995)

Flaubert, Gustave, *Three Tales*, translated by A. J. Krailsheimer (Oxford: Oxford University Press, 1991)

Fuller, Peter, interview with David Hockney, 1977, http://www.laurencefuller.art/blog/2015/7/14/david-hockney-interview

Gogh, Vincent van, The Letters http://vangoghletters.org/vg/letters.html

Golding, John, *Braque: The Late Works*, exhibition catalogue (London: Royal Academy of Arts, 1997)

Gooley, Tristan, *How To Read Water: Clues and Patterns from Puddles to the Sea* (London: Sceptre, 2017)

Harford, Tim, *Messy: The Power of Disorder to Transform Our Lives*, 2016

Hicks, Carola, *The Bayeux Tapestry: The Life Story of a Masterpiece* (London: Chatto & Windus, 2007)

Hockney, David, *David Hockney by David Hockney* (London: Thames & Hudson, 1976)

Hockney, David, 'Picasso: Important Paintings of the 1960s', lecture, Solomon R. Guggenheim Museum, New York City, 3 April 1984, https://www.guggenheim.org/audio/track/picasso-important-paintings-of-the-1960s-by-david-hockney-1984

Hockney, David, *That's the Way I See It* (London: Thames & Hudson, 1993)

Hockney, David and Martin Gayford, *A History of Pictures: From the Cave to the Computer Screen* (London: Thames & Hudson, 2016)

Joyes, Claire, *Monet at Giverny* (London: W. H. Smith, 1978)

Kenkō and Chōmei, *Essays in Idleness and Hojoki*, translated by Meredith McKinney (London: Penguin, 2013)

Klein, Daniel, *Travels with Epicurus: Meditations from a Greek Island on the Pleasures of Old Age* (London: Oneworld Publications, 2013)

Morton, Oliver, *The Moon: A History for the Future* (London: Economist Books, 2019)

Nicolson, Benedict, *Courbet: The Studio of the Painter* (London: Allen Lane, 1973)

Otero, Roberto, *Forever Picasso: An Intimate Look at his Last Years* (New York: Harry N. Abrams Inc., 1974)

Ross, Alex, *Wagnerism: Art and Politics in the Shadow of Music*, London, (London: 4th Estate, 2020

Rousseau, Jean-Jacques, *Reveries of the Solitary Walker*, translated by Peter France (Harmondsworth: Penguin, 1979)

Shattuck, Roger, *Proust's Binoculars: A Study of Memory, Time and Recognition in 'À la Recherche du Temps Perdu'* (New York: Random House, 1963)

Spender, Stephen, *New Selected Journals, 1939–1995*, edited by Lara Feigel, John Sutherland, and Natasha Spender (London: Faber and Faber, 2012)

Zalasiewicz, Jan, *The Planet in a Pebble: A Journey into Earth's Deep History* (Oxford: Oxford University Press, 2012)

Sources

p. 45 'In the corners there were huge rolls': Nicholson, p. 23

p. 45 '"Everything", he declared, "is subject to metamorphosis"': Golding, p. 9

p. 46 '"I am in the middle of my canvases"': ibid., p. 73

p. 56 Stephen Spender's visits to Paris: Spender, entry for 15 March 1975

pp. 63–4 '"the untidy, unquantified, crude, cluttered, uncoordinated"': Harford, p. 5

p. 64 'As he walked over to La Coupole': Spender, op. cit.

p. 65 '"I'd always thought of him as a rather minor artist"': Fuller, n.p.

p. 67 '"I thought the one thing the French were marvellous at"': Hockney, 1993, p. 53

p. 68 '"In the Pavillon de Flore, they had an exhibition"': Hockney, 1976, p. 285

p. 96 '"how a horse clambers out of a ship"': Hicks, p. 4

pp. 132–3 '"At one side of my little house at Malibu"': Hockney, 1993, p. 196

pp. 135–7 '"The house to the left is pink, with green shutters"': Van Gogh, Letter 691, on or about 29 September 1888

p. 137 "'as would be the bottoms of bottles, of bricks of rounded glass – purple glass'": Van Gogh, Letter 681, 16 September 1888

p. 137 "'Without changing anything at the house, either now or later'": ibid.

p. 138 "'You know that the Japanese instinctively look for contrasts'": Van Gogh, Letter 678, 9 and about 14 September 1888

p. 139 "'nothing special – a round cedar or cypress bush – planted in grass'": Van Gogh, Letter 689, 26 September 1888

p. 153 "'Every second, 16 million tonnes of water'": Morton, p. 21

p.161 "'to express the love of two lovers through a marriage of two complementary colours'": Van Gogh, Letter 673, 3 September 1888

p. 163 "'The use of blacks as a colour'": Flam, p. 106

p. 168 "'It isn't just the sense of volume': Hockney and Gayford, p. 275

p. 168 "'There *is* a difference between painting that veers towards music'": Fuller, n.p.

pp. 171–2, "'He's followed through on the dense blue, green, black, and red'": Roberta Smith, *New York Times*, 23 November 2017

p. 188 "'there is frequently a curious illusion'": Arthur Mason Worthington, A Study of Splashes (London: Longmans, Green, and Co., 1908, p. 31

p. 190–1 "'we can learn a lot about what is going on in the world's greatest oceans'": Gooley, p. 10

p. 194 "'There the noise of the waves'": Rousseau, p. 86

p. 202 "'Concentration is so intense'": Csikszentmihalyi, p. 71

pp. 210–11 "'The current of the flowing river'": Kenkō and Chōmei, p. 5

pp. 211–13 "'I believed that two canvases would suffice, one for grey weather'": Joyes, p. 9

p. 213 "'I am working terribly hard, struggling with a series of different effects'": ibid.

p. 212 "'I know beforehand that you'll say my pictures are perfect....'": Joyes, p. 39

p. 223 "'a godfather of modern art'": Ross, p. 69

p. 230 "'with his purple wings and emerald body'": Flaubert, p. 14

p. 230 "'she thought she saw'": ibid., p. 40

p. 230 "'his body was green, his wingtips pink'": ibid., p. 28

p. 232 "'Why, one can see that easily enough'": Hans Christian Andersen Centre, https://andersen.sdu.dk/vaerk/vaerk/hersholt/TheDropOfWater_e.html, n.p.

pp. 234–5 "'The emperor of China lives in a porcelain palace'": 'Le Rossignol', as told by David Hockney, http://www.saltsmill.org.uk/pdf/le_rossignol.pdf

p. 235 "'They are fascinating, the little stories'": Hockney, 1976, p. 195

p. 237 "'she did not understand'": Flaubert, p. 15

pp. 241–3 "'It's an incredibly unique document'": Hockney, 1984, n.p.

p. 243 "'no end inventing these stories'": Otero, p. 170

p. 247 "'M. Verdurin's character offered me'": Shattuck, p. 23

p. 255 "'Nothing can exceed the beautiful appearance'": Constable, p. 78

Acknowledgments

The largest debt of thanks I owe is to the subject of this book, David Hockney, for the generosity with which he has shared his thoughts, work, time, and friendship with me over many years – and especially in the last two. Jean-Pierre Gonçalves de Lima and Jonathan Wilkinson, David Dawson, and my wife Josephine also contributed valuable ideas, photographs, and enthusiasm. Some of my thoughts about art under lockdown first appeared in the *Spectator*, thanks to the encouragement of the arts editor, Igor Toronyi-Lalic. I would also like to thank Martin Kemp and Jonathon Brown for the illumination that I gained from conversations with them.

My son Tom kindly undertook the task of looking through the earliest and roughest drafts of the book. Andrew Brown did an impeccable job of editing the text and laying out the design. And as always, Sophy Thompson, my publisher at Thames & Hudson, was supportive from the moment that I first mentioned this project.

List of illustrations

List of illustrations

List of illustrations

Index